The Campus History Series

MEHARRY
MEDICAL COLLEGE

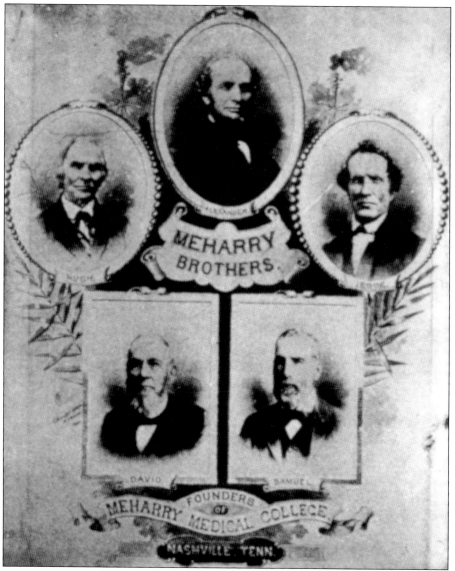

The Meharry brothers gave the initial investment of $30,000 enabling the establishment of the Meharry Medical Department of Central Tennessee College. The brothers' investment brought a marvelous return. (Courtesy of the Meharry Medical College Archives.)

ON THE COVER: In 1879, a third year was added to the course in medicine. The requirements for graduation added that students must have studied three years under a regular physician in good standing and specified that the last year must be spent at Meharry. Pictured are students in 1949 studying with physician Dr. G.H. Martin. (Courtesy of the Meharry Medical College Archives.)

COVER BACKGROUND: In 1917, the Anderson Anatomical Laboratory was dedicated. Shown are the many Meharrians who participated in the ceremonial ground breaking. (Courtesy of the Meharry Medical College Archives.)

The Campus History Series

MEHARRY
MEDICAL COLLEGE

SANDRA MARTIN PARHAM

ARCADIA
PUBLISHING

This story of Meharry is dedicated to the vanguard who had the vision to initiate Meharry Medical College to meet the needs of a destitute community; the trustees, presidents, administrators, researchers, faculty and staff who served at Meharry, the students who carried the Meharry torch, and those whose future will become a part of "the spirit of this place called Meharry." (Courtesy of the Meharry Medical College Archives.)

CONTENTS

ACKNOWLEDGMENTS

The opportunity to end my career in librarianship by working at the Meharry Medical College Library and Archives has been a godsend. Subsequently, to write and compile this history of Meharry has been a great privilege. I would like to thank the college president, Dr. James E.K. Hildreth, and the vice president for student affairs and executive director of the Center for Health Policy, Dr. Samuel Dexter, for this golden opportunity to become a Meharrian.

I gratefully acknowledge Jewell B. Parham, Donnie Jennings, Clare Kimbro, and Vanessa Smith for their invaluable assistance in the production of this book. Thanks and appreciation are also extended to Dr. Henry A. Moses, on whose institutional memory I relied in identifying images. Finally, my sincere gratitude to the former archivists and librarians who provided documents that became an important source for the captions in this work.

All sources are from the Meharry Medical College Library and Archives collections, including the varied histories noted in the bibliography. All photographs and sketches are also from the archives and other campus resources, unless otherwise noted.

Dr. C.V. Roman, one of Meharry's earliest historians, stated, "When high aims accomplish useful deeds, we have human character at its best." The history of Meharry illustrates all this. Conceived in philanthropy, Meharry was born in gratitude and reared in altruism.

INTRODUCTION

During the decade following the Civil War, those charged with the task of providing schools for the freedmen quickly recognized the almost total lack of competent medical service for African Americans, among whom the mortality rate was mounting with alarming rapidity. It was to cope with this situation that Meharry, in 1876, came into being as the Medical Department of Central Tennessee College at Nashville, which had been established nine years earlier by the Freedman's Aid Society of the Methodist Episcopal Church.

It was the kindness displayed to a white man by an unknown freed black man that prompted the gift that made Meharry possible.

The legend is that in 1826, 16-year-old Samuel Meharry, en route home in a salt-laden wagon, one evening found himself mired on a muddy country road. A free black man who lived nearby came to Meharry's rescue but was unable to get the wagon free before nightfall. Taking Meharry in, the man provided him with food and shelter for the night, and the next morning helped him to free the wagon. It is recorded that, in bidding his benefactor goodbye, Samuel Meharry vowed, "I hope someday to repay your kindness by doing something for your people."

In 1875, when Rev. John Braden, president of Central Tennessee College, sought funds for the establishment of a medical department for the training of black students, he appealed directly to Samuel Meharry. Meharry saw this as his chance to keep the vow he had made years earlier to do something for the black race.

Ultimately, Samuel Meharry and his four brothers gave more than $30,000 to this cause, enabling the establishment of the Meharry Medical Department of Central Tennessee College.

The college grew out of an unusual set of post–Civil War circumstances. During the final months of the war, a friendship developed between an Army of Northern Virginia medical corpsman, George W. Hubbard, and a Confederate army surgeon, Dr. J.W. Sneed. During a period of truce, the two men became acquainted, and a mutual bond and respect was established. Hubbard promised to come to Nashville, Sneed's home, and to enter medicine under Dr. Sneed's tutelage after the war. George W. Hubbard kept his word and stayed in Nashville after the war ended and attended Nashville Medical School, which later became Vanderbilt Medical School.

In 1876, Dr. George W. Hubbard and Dr. J.W. Sneed joined the Meharry Medical Department of Central Tennessee College and became two of the first instructors in the new department. In 1900, Central Tennessee College became Walden University, and Meharry continued as

its medical department until 1915, when it was incorporated independently as Meharry Medical College.

Dr. Hubbard, who up to this time was dean of the department, now assumed the title of president and continued to serve in that capacity until his resignation in 1921.

During its early years, Meharry Medical College was in the southern section of Nashville and was housed in several small buildings, which were nevertheless adequate for its needs.

As the college continued to grow, it became imperative that a new campus be built on a larger site. Property was acquired in northwest Nashville, directly across from Fisk University, where a modern school and hospital were erected in 1931.

Meharry's early striving for both equality and excellence grew out of the expression attributed to W.E.B. Dubois that black people should be able to do anything as well as white people. Meharry's mission focused on enabling black people to become both community leaders and medical practitioners. The founders hoped that the religious aspect of healing would also be expressed. As a result, many of the graduates were ministers or highly religious physicians.

Today, Meharry occupies a unique place. It was founded, above all, to meet a need for educating practicing physicians, dentists, and nurses who would care for their own race. That need has not diminished over the years. Today, Meharry Medical College is serving not only one section, but all sections of the communities in which its graduates practice.

Meharry proceeds with its work—with rightful pride for what it has achieved and in rightful humility before the ends it tries to serve—in keeping with the inscription on its cornerstone: "Dedicated to the worship of God through service to man." The following pages are designed to review the history of this institution—what it has done in that service, is doing, and has yet to do.

One

PRES. GEORGE W. HUBBARD
1876–1921

In October 1876, Dr. George Whipple Hubbard became the first president of the Meharry Medical Department of Central Tennessee College. Meharry's dental and pharmaceutical departments were organized in 1886 and 1889. In 1910, the School of Nursing of Mercy Hospital was transferred to Meharry under Hubbard. On October 13, 1915, Meharry Medical College was granted a charter separate from Central Tennessee during his administration. In 1917, the George W. Hubbard Hospital was built and named in his honor. Dr. Hubbard retired in 1921.

In October 1876, Hubbard joined with W.G. Sneed, a former Confederate army surgeon, and began educating former slaves and children of slaves. Meharry's early graduates returned to the disease-ridden city streets and the impoverished countryside of the post–Civil War South to provide medical assistance.

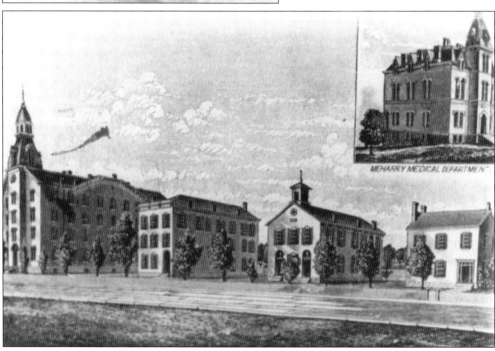

The Meharry Medical Department of Central Tennessee College was organized in 1876 through the efforts of Dr. G.W. Hubbard, Dr. William J. Sneed, and Samuel Meharry for the purpose of giving African Americans an opportunity to obtain a medical education in the South.

This bronze marker provides a succinct history of the origin of Meharry Medical College. The marker was given in commemoration of the buildings erected under the presidency of Meharry's second president, Dr. James Mullowney.

THE NAME OF THIS COLLEGE
TRACES ITS ORIGIN TO THE
GENEROUS PHILANTHROPIC CHRISTIAN
FAMILY OF MEHARRY BROTHERS
ALEXANDER·DAVID·HUGH·JESSE·SAMUEL.

MEHARRY MEDICAL COLLEGE
WAS ORGANIZED IN
1876
AS A DEPARTMENT OF
CENTRAL TENNESSEE COLLEGE
UNDER THE PRESIDENCY OF THE
REVEREND JOHN BRADEN

DOCTOR GEORGE WHIPPLE HUBBARD
SERVED AS DEAN FROM 1876 TO 1915
AT WHICH TIME THE COLLEGE
RECEIVED AN INDEPENDENT CHARTER
FROM THE STATE OF TENNESSEE

HE THEN BECAME PRESIDENT, SERVING
FAITHFULLY UNTIL HIS RETIREMENT
IN 1921

DOCTOR JOHN JAMES MULLOWNEY
WAS CALLED TO THE PRESIDENCY
FEBRUARY 1, 1921
IT WAS DURING HIS ADMINISTRATION
THAT THESE BUILDINGS WERE ERECTED

Tennessee Hall, the name given to the college's main building, contained four stories and was dedicated on October 14, 1880. The first medical students met for recitation and laboratory work in a small room here.

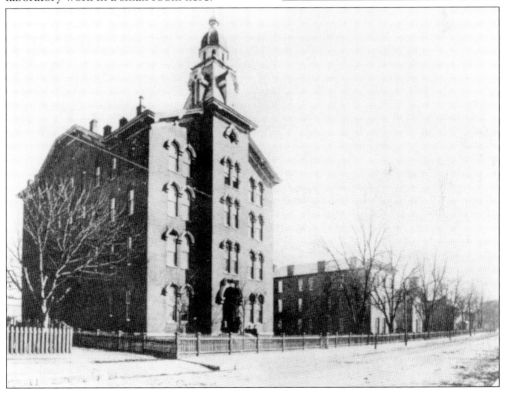

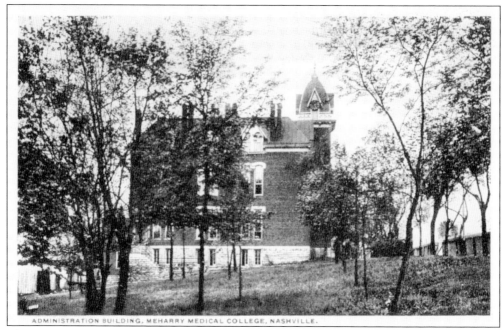

ADMINISTRATION BUILDING, MEHARRY MEDICAL COLLEGE, NASHVILLE.

This postcard featuring the prominent administration building is dated 1918. The description of the back reads, "Meharry, the oldest and perhaps largest Medical College for colored students in the World is located at the corner of First Avenue South and Chestnut Street. Its enrollment of between 500 and 600 students represents almost every state in the Union, and several Foreign Countries. Its courses comprise Medicine, Dentistry, Pharmacy and Nurse-Training."

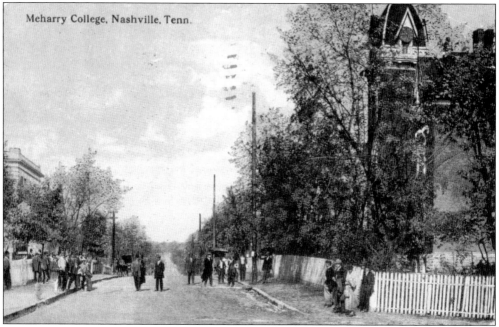

Meharry College, Nashville, Tenn.

This rare postcard shows Meharrians in front of Tennessee Hall. The photograph was taken in the late 1800s.

In 1876, Meharry Medical College was organized as the Medical Department of Central Tennessee College. In 1900, the name was changed to Meharry Medical College of Walden University.

CATALOGUE

OF THE

Central Tennessee College,

NASHVILLE, TENNESSEE.

1879-80.

NASHVILLE, TENN.
LIGON & CO., 23 PUBLIC SQUARE, PRINTERS.
1880.

MEHARRY
MEDICAL, DENTAL AND PHARMACEUTICAL
COLLEGES.

MEHARRY MEDICAL COLLEGE.

WALDEN UNIVERSITY.
NASHVILLE, TENNESSEE

The early catalogs of the college include the name Walden University of Nashville.

ALUMNI.

CLASS OF 1877.

Jamison, J. M Topeka, Kan.

CLASS OF 1878.

Bass, John Silas Murfreesboro, Tenn.
Halfacre, John C Columbia, Tenn.
Key, Lorenzo Dow Mason, Tenn·

CLASS OF 1879.

Andrews, James P Chattanooga, Tenn.
Anderson, George M Memphis, Tenn.
Ballard, Joseph H Jeffersonville, Ind.
Jones, William P. T St. Louis, Mo.
McKinley, John F Austin, Texas.
Noel, Henry T Nashville.
Scruggs, Burgess E Huntsville, Ala.
White, James E Dyersburg, Tenn.

CLASS OF 1880.

Denny, William B Nashville
Hadley, William A Nashville.
McClellan, John B Murfreesboro, Tenn.
McKinney, George W Chattanooga, Tenn.
Napier, Henry A* Nashville.
Ramsey, Edwin B Houston, Texas.
Smith, Charles S Bloomington, Ill.
Wilkins, John H Galveston, Texas.

CLASS OF 1881.

Neal, Quinton B Austin, Texas.
Patton, James H* Nolensville, Tenn.
Upshaw, Thomas I Washington, D.C.

CLASS OF 1882.

Asbury, James E Atlanta, Ga.
Ballard, Wade H New Middleton, Tenn.
Banks, Albert G Vicksburg, Miss.
Boyd, Robert F Pulaski, Tenn.
Durham, Jacob L., A. B Columbia, S.C
Gunn, William J Tallahassee, Fla.
Phillips, Charles H., A.B Jackson Tenn.
Walker, John C Memphis, Tenn.

CLASS OF 1883.

Fearn, Lee Roy Huntsville, Ala.
McMorris, Zebulon Wallace Newberry, S.C.
Mullon, Isaiah Eugene, A.B New Orleans, La.
Robey, Franklin Reese Mobile, Ala.
Wright, Cea Kenchen Savannah, Ga.

During the 1860s, more than 95 percent of Meharry's faculty were black physicians. The faculty had grown from one man, Dr. G.W. Hubbard, assisted by Dr. W.J. Sneed, to 35 trained physicians. The course of study at that time consisted of two years and five months. The requirement for admission was a very ordinary English education. Nine students enrolled during the first session.

FIRST GRADUATE

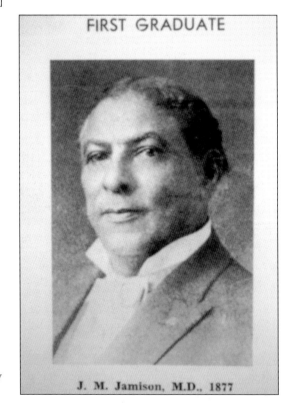

J. M. Jamison, M.D., 1877

James Monroe Jamison was the first graduate of Meharry Medical College in 1877. He was born in either 1851 or 1853 and thus was about 25 when he became a doctor. In 1880, he was elected the first president of the State Colored Medical Association, formed by Meharry's early graduates.

This list of the 1879–1880 Meharry Medical Department faculty is from the 1879 catalog. This is one of the earliest lists of the names of faculty members. The majority were former students of the college.

MEHARRY

MEDICAL DEPARTMENT.

FACULTY

J. BRADEN, D.D., *President.*

N. G. TUCKER, M.D.,
Professor of Theory and Practice of Medicine.

W. J. SNEED, M.D.,
Professor of Surgery and Surgical Anatomy.

JAMES B. STEPHENS, M.D.,
Professor of Obstetrics and Diseases of Women.

G. W. HUBBARD, M.D.,
Professor of Chemistry, Materia Medica and Therapeutics.

Hon. JOHN LAWRENCE,
Professor of Medical Jurisprudence.

J. F. McKINLEY, M.D.,
Demonstrator of Anatomy.

In addition to the regular Faculty lectures have been delivered during the past session by E. M. Wight M. D., of Chattanooga, Col. Geo. Waring of Newport, R. L, Dr. Mussey of Cincinnati, Wm. H. Morgan M. D., D. D. S., W. P. Jones M. D., W. K. Bowling M. D., and several other distinguished physicians of Nashville.

All letters of inquiry concerning this Department should be addressed to

G. W. HUBBARD, M.D.,
Dean of the Faculty.

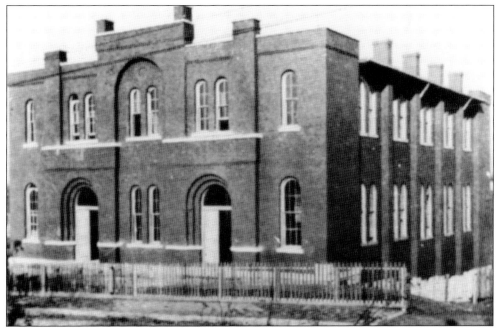

The Meharry Auditorium was north of Meharry Medical College. It had a width of 62 feet and a length of 91 feet, and the foundation rested on solid rock. The walls of the basement were built of stone and were 10 feet in height. The building was well lit and was used for laboratory purposes.

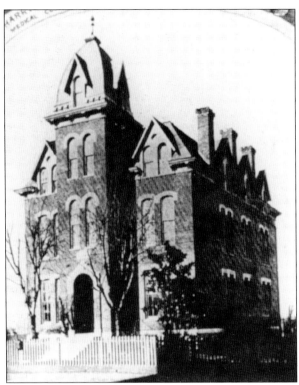

The medical department building was constructed in 1879–1880. The ground floor was used as a chemistry laboratory; the second story held offices, a museum, and apartments; the third floor contained a lecture room big enough for 100 students and a recitation room; and the fourth floor had another lecture room.

In 1884, upon the urging of some of the first alumni, the trustees directed Central Tennessee College officials to investigate the practicality of dental studies. Two years later, a new course was offered within the Meharry Medical Department. In October 1889, the School of Pharmacy of the Meharry Medical Department opened in specially prepared rooms in the new dental building.

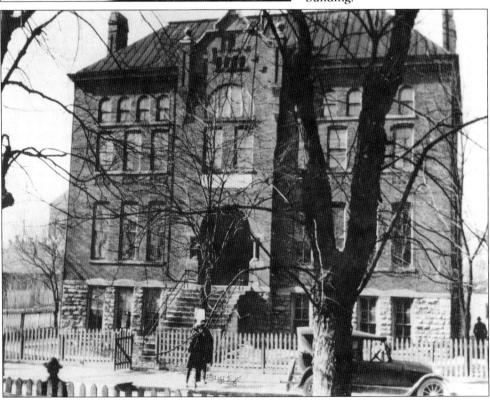

The Dental and Pharmaceutical Hall was built in 1889. It contained a dental operatory, two dental laboratories, and a reading room. There were three rooms for pharmaceutical work, a laboratory for analytical chemistry, and a histological and pathological laboratory. The building also included a clinical amphitheater with waiting rooms for patients, a recitation room, and a museum. The announcement of the new pharmacy program promised to confer the degree of graduate of pharmacy (PhG) for those who completed two 22-week sessions, passed their examinations, and possessed four years' experience compounding drugs and medicines in a pharmacy. The first pharmacy students were required to study botany, medical chemistry, toxicology, medicine, microscopy, pharmacy, and urinalysis. During the first session, in addition to daily recitations, students performed experiments in the chemical lab that was shared with the dental students.

First-year dental students had the same grueling schedule as the pharmacy students. They recited daily in anatomy, chemistry, and physiology, then worked two hours in the chemical laboratory and one hour in the dental infirmary. In the second year, the curriculum continued with anatomy, *materia medica*, hygiene, and practical work in the lab or dissecting room. Before a student could graduate in dental studies, they were required to treat a patient in all dental operations while being observed by professors. Students also had to pass an examination before the dental faculty. Each student was also required to prepare a specimen case to be placed in the museum.

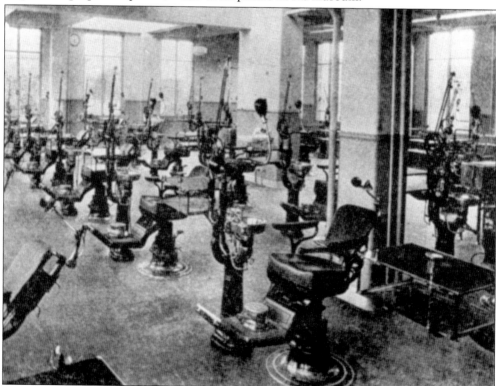

By 1882, the graduating class numbered eight, and among them was Robert F. Boyd, perhaps the greatest Meharry graduate of the 19th century. Dr. Boyd was the first black doctor to open a private practice in Nashville. He helped found the National Medical Association, the first organization of black physicians in the United States, and became its first president in 1895.

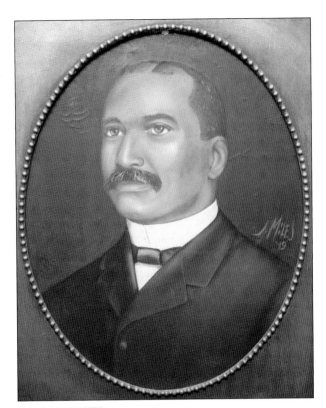

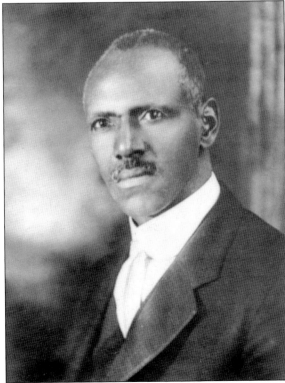

For more than a quarter of a century, Dr. James B. Singleton, who received a doctor of dental surgery (DDS) from Meharry in 1892, served as the head of dentistry at his alma mater. The success of the dental school during its early years is credited to him.

GRADUATES OF 1890.

Bluitt, L. B.	Waco, Texas.
Butler, H. R., A.B.	Atlanta, Ga.
Baker, T. J.	Helena, Ark.
Crosthwait, D. N., A.M.	Nashville, Tenn.
Crossland, J. R. A.	St. Joseph, Mo.
Cooke, B. J.	Knoxville, Tenn.
Goin, J. B.	Birmingham, Ala.
Gray, D. L.	Dickey, Ark.
Love, A. J.	Chattanooga, Tenn.
Perry, A. F.	Chattanooga, Tenn.
Roman, C. V.	Nashville, Tenn.
Slater, T. H., A.B.	Atlanta, Ga.
Turpin, J. M., A.M.	Nashville, Tenn.
Wright, L. M.	Knoxville, Tenn.

MIDDLE CLASS.

Burruss, G. S.	Martin, Ga.
Cook, H. W.	Pine Bluff, Ark.
Curtis, W. P.	Marion, Ala.
Cain, C. I.	Ocala, Fla.
Crawford, J. P.	Pulaski, Ala.
Darden, E. P.	Spring Hill, Tenn.
Davis, J. D.	Richmond, Texas.
Foster, J. S.	Spring Hill, Tenn.
Green, W. T.	Huntsville, Texas.
Johnson, J. W.	Park Place, Ark.
Lockhart, A. O.	Jonesboro, Ga.
Lynk, M. V.	Brownsville, Tenn.
McTier, A. B.	Bells, S. C.
Merritt, C. G.	Mexia, Texas.
Queen, O. C.	Kosse, Texas.
Robinson, C. S.	Tallahassee, Fla.
Sumner, S. H.	Nashville, Tenn.
Thompson, W. S.	Nashville, Tenn.
Walker, M. T.	Martinsville, Va.
Warren, W. F.	Tyler, Texas.
White, J.	Nashville, Tenn.

JUNIOR CLASS.

Baker, W. R.	Gallatin, Tenn.
Ball, J. D.	Dundas, Ontario.
Brown, W. A.	Greensboro, N. C.
Cotton, J. A.	Memphis, Tenn.
Crawford, E. B.	Marion, S. C.
Derrick, W. W.	Huntsville, Ala.

Charles Victor Roman (1864–1934), one of the founders of the National Medical Association, also founded the first Department of Ophthalmology and Otolaryngology in 1904. Dr. Roman authored one of the earliest works on the history of Meharry, *History of Meharry Medical College*, published in 1934.

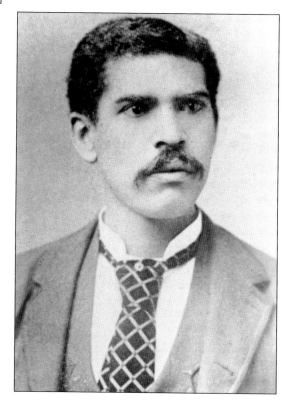

The first class in pharmacy graduated in 1890. The first pharmacy graduate recruited to teach was Dr. William Sevier, a member of the class of 1892. Subsequently, he earned a doctor of medicine degree in 1898 and a diploma from the Northwestern College of Pharmacy in Chicago.

Dr. Georgia Esther Lee Patton Washington was the first female graduate of Meharry Medical College. She was born in Grundy County, Tennessee, in 1864. After completing the normal course at Central Tennessee College in 1890, she entered the Meharry Medical Department that fall. Upon her graduation, she became the first black woman to receive a license to practice medicine and surgery in Tennessee. Three months later, in May 1893, she sailed for Liberia, the first Meharrian to go to Africa. Failure of health and lack of financial support forced Dr. Patton to return to the United States in 1895, where she enjoyed a lucrative practice in Memphis, Tennessee.

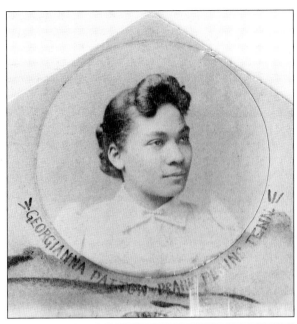

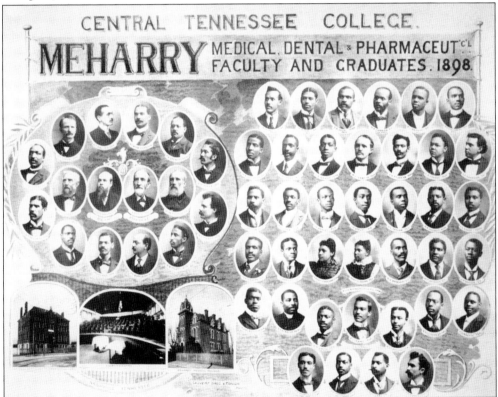

This composite photograph of the class of 1898 shows the early years of growth of the college. Many of these students remained in Nashville after graduation. Dr. Hubbard's express desire for a hospital at Meharry arose in part from his compassion for the sick black people of Nashville.

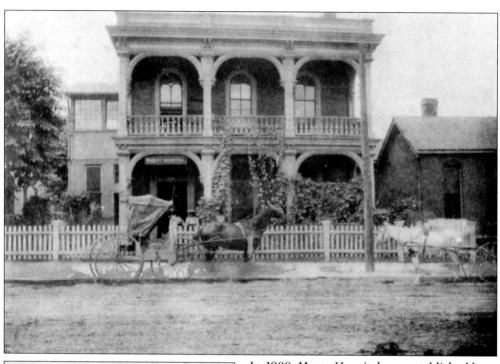

MEHARRY
Medical, Dental and Pharmaceutical
COLLEGES.

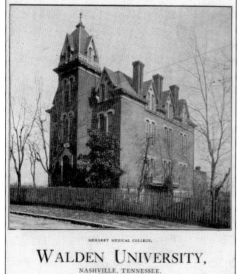

MEHARRY MEDICAL COLLEGE.

WALDEN UNIVERSITY,
NASHVILLE, TENNESSEE.

Catalogue of 1904-1905—Announcement
for 1905-1906.

NASHVILLE, TENN.:
MARSHALL & BRUCE CO., PRINTERS.
1905.

In 1900, Mercy Hospital was established by Dr. R.F. Boyd. Dr. Boyd allowed the hospital to be used by Meharry for the purpose of training nursing students and for giving clinical experience to the medical students. It was a two-story structure of 12 rooms and contained 23 beds. The hospital was under the management of the faculty of Meharry, and the senior students served as interns. The nurses who trained at Meharry College were also the nurses who served Mercy Hospital. It served until 1910 as the teaching hospital for students and nurses, at which time Meharry provided one of its own, Hubbard Hospital.

The 1905–1906 catalog cover features a picture of the first medical school. The catalog lists graduates as well as admission requirements. As the college grew, documentation of the alumni became a priority.

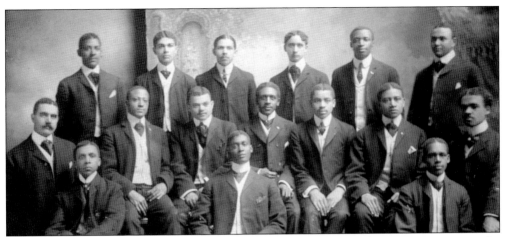

A distinguished group, the 1906 class of sophomores is assembled in this photograph. The students dressed formally to attend class.

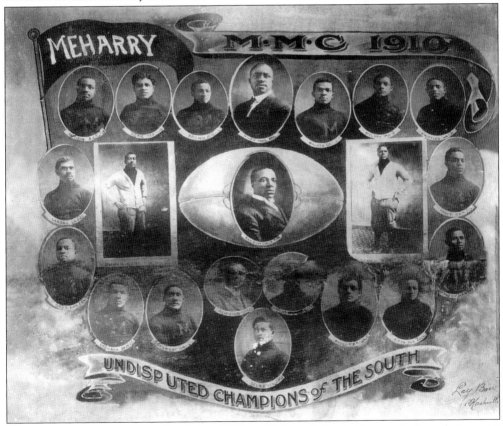

Pictured is a rare photograph of the Walden (Meharry) football team before their game against Atlanta Baptist College on Thanksgiving day, November 29, 1906. No sporting event in Nashville had ever commanded such crowds and enthusiasm among the African American population as the Meharry-Fisk game. It became a north Nashville–south Nashville rivalry as Meharry was then in south Nashville and Fisk in north Nashville. The Meharry faculty later decided that intercollegiate sports were not proper for a professional school.

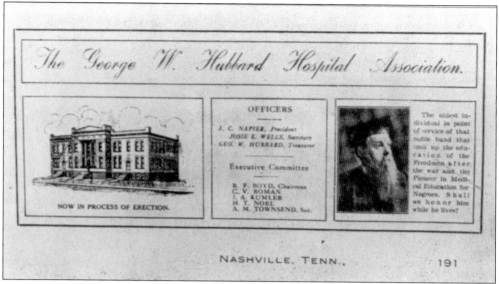

This letterhead was designed to be used to solicit funds for the 1910 Hubbard Hospital fundraising campaign. It featured Dr. Hubbard's portrait and a sketch of the proposed hospital building.

The library contained about 900 bound volumes and 4,000 unbound books and pamphlets. A great portion of the holdings was a gift from Dr. W.H. Massey of Cincinnati, Ohio.

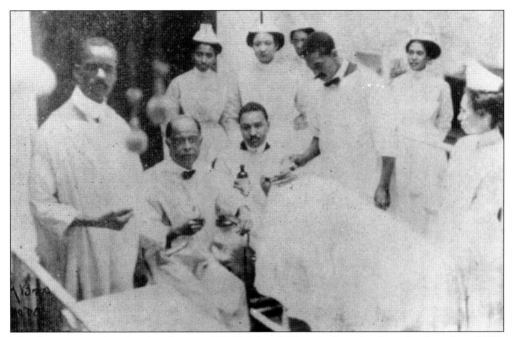

The first operation in the George W. Hubbard Hospital took place in October 1910. Previous to this, operations were performed at Mercy Hospital.

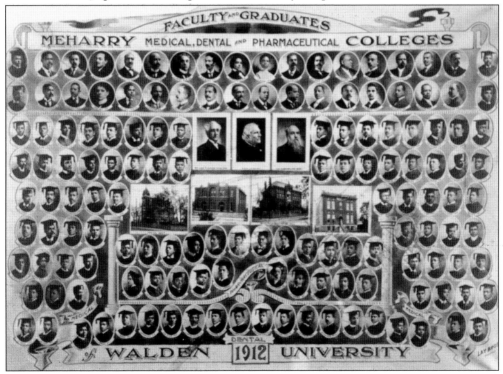

The class of 1912 was special. In that year, the Nashville Board of Trade was initiated. The board sponsored several health priorities, including a cleanup campaign in the black district and the hiring of a black nurse in Nashville's health department.

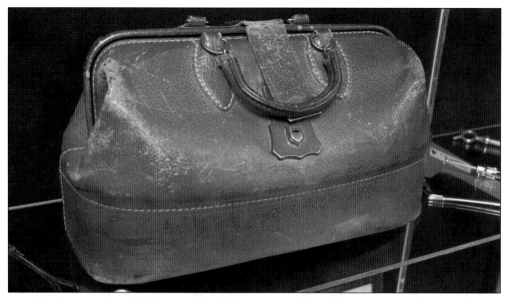

On October 13, 1915, Meharry Medical College was incorporated under a new and separate charter. The purpose of a new charter was to make the college more secure financially and to provide for improvement of the quality of its programs and services and the expansion of its physical facilities.

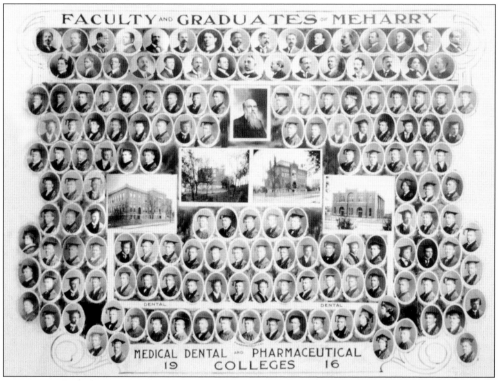

When Dr. Charles Roman, speaking at Dr. Hubbard's investiture in 1916, told of his hope that the president's vision upon Hubbard's retirement would fall on some worthy alumnus of Meharry, the applause was tremendous.

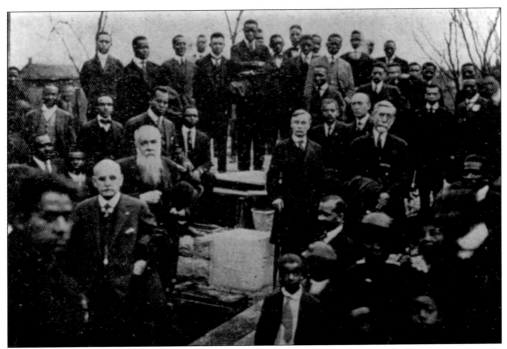

In October 1917, the John A. Anderson Anatomical Laboratory was dedicated with appropriate pomp and ceremony. This photograph is of trustees, Dr. Hubbard, faculty, and students gathered to witness the ground breaking.

The John A. Anderson Anatomical Laboratory was the first major tangible expression of love and loyalty on the part of one of Meharry's graduates, John A. Anderson (MD, 1885; DDS, 1887). Pictured here are Dr. and Mrs. Anderson. Out of a desire to show their appreciation for what had been done for them and to show their loyalty to their alma mater, they donated $10,000 to build the Anderson Anatomical Laboratory.

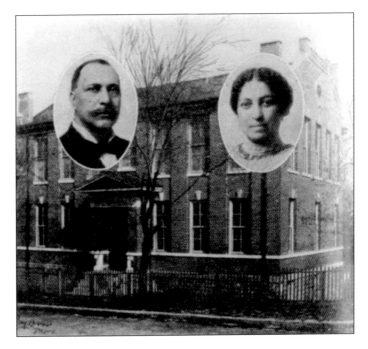

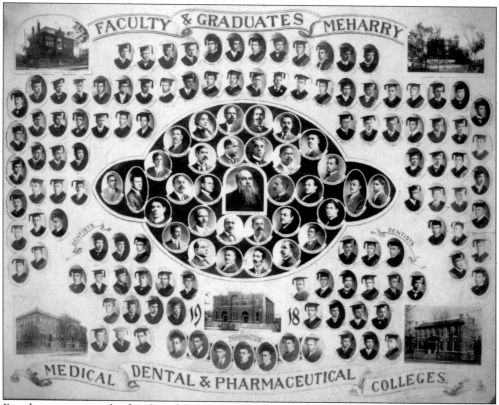

For the most part, the faculty of Meharry were all alumni of the college. Before returning to Meharry to teach, many worked at northern and eastern universities in order to keep up with the latest methods that were taught in leading medical schools.

President Hubbard tendered the services of the entire senior medical class, the student body, and the complete equipment of the college to the winning of World War I. According to the 1919 *Meharry Annual Military Review*, "The school rendered invaluable service for the cause of 'Uncle Sam' and was also utilized for the care of the sick and wounded colored soldiers in the war."

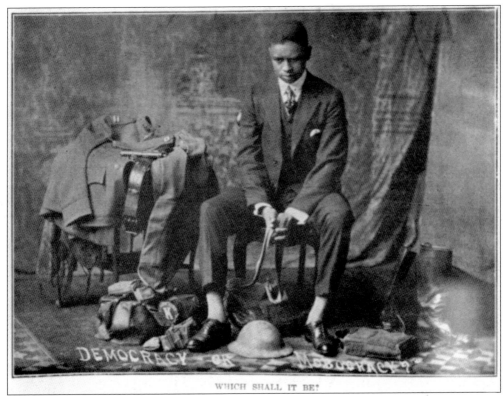

WHICH SHALL IT BE?

Doctors who graduated from Meharry interrupted their careers to join the Army during World War I. This photograph depicts the reality of war. With a medical bag on the floor and an Army uniform by his side, J. Arthur Kennedy, graduate of the Pharmaceutical and Medical Department of Meharry, contemplates the meaning of the challenge. He attained the rank of captain and served as surgeon of the 366th Infantry, 2nd Battalion, 92nd Division. He was recommended for the Distinguished Service Cross for exceptional valor and meritorious service.

During the time the Hubbard Training School for Nurses was established, a nurses' home was built to accommodate the faculty, staff, and student nurses. Graduate registered nurses, one dietitian, a matron of the home, and 60 pupils resided here.

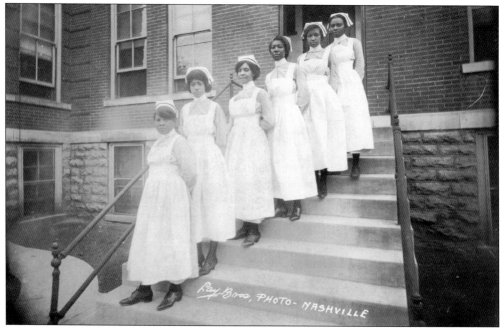

The nurse training class of 1918 represents the many Meharry nurses who also volunteered in World War I. It is stated in the *Meharry Annual Military Review* that they served Uncle Sam and rendered valuable service in government hospitals. "Our nurses proved 100 percent loyal to the cause," the article read.

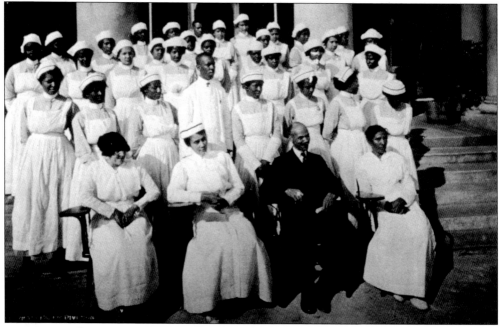

In 1910, with the completion of Hubbard Hospital of Meharry Medical College, a professional course consisting of three years was instituted. Classes were taught principally by members of the faculty of Meharry Medical College. Here, Dr. Boyd is seated, surrounded by nurses and his pet dog under his chair.

Twelve students enrolled in the first Hubbard Training School for Nurses, as the nurse education program was called. Hulda M. Lyttle was a graduate of the class of 1912. Returning to Meharry in 1916 after a teaching post at the Southern University School of Nursing, Lyttle was named director of nurse training. In 1921, she was named superintendent of Hubbard Hospital. Although her title and the name of the department changed, she remained head of the nursing program for more than 20 years. Several new courses of instruction were added to the nursing curriculum by 1920, and two years later, the entrance requirements were raised to the completion of a four-year high school course. In addition to mastering nursing subjects, teacher's training was required of faculty members. Below are nursing students with their instructor, nurse B. Whitman.

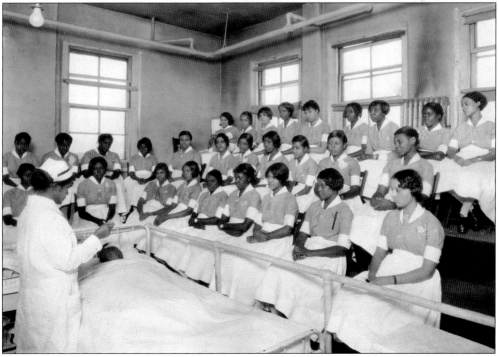

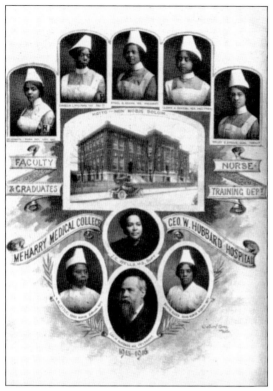

When the first class graduated in 1912, Hubbard nurses attempted to take the examination required for a license from the State of Tennessee. The secretary of the licensing board refused to administer the test to them. Protests by black citizens led state officials to reconsider the prohibition. In 1914, Meharry's nursing graduates were allowed to take the exam. The examination covered more than 10 nursing subjects. Meharry nurses who took the exam all earned passing grades. Pictured at left are nurse graduates of the Hubbard Training School for Nurses. Josie Wells, MD, superintendent of nursing, is pictured at bottom left next to Dr. Hubbard. Dr. Wells, class of 1904, was the first woman to teach at Meharry and the first to attain a position of leadership. Prior to studying medicine, Wells received training as a nurse. She devoted herself entirely to diseases of women and children.

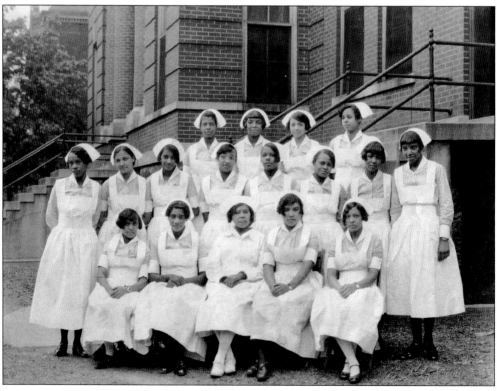

By 1920, entrance requirements were raised; however, the nursing program thrived. During these early years, more than 200 women had graduated in nursing and were established in nursing practices in nearly every state in the Union.

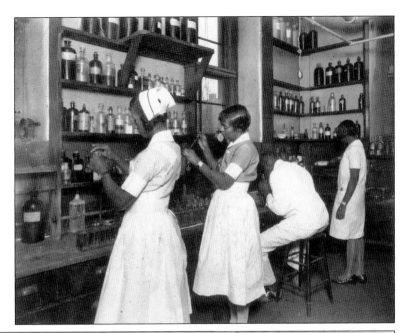

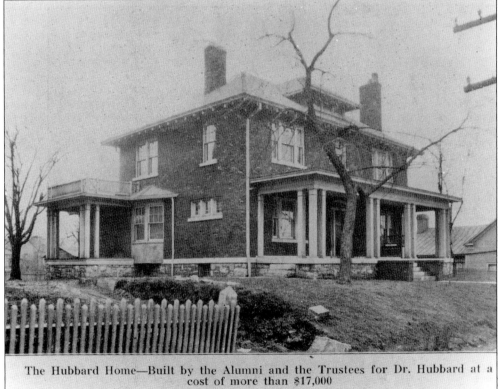

The Hubbard Home—Built by the Alumni and the Trustees for Dr. Hubbard at a cost of more than $17,000

The Hubbard Home in south Nashville was built upon the retirement of Dr. Hubbard in 1921 at a cost of more than $17,000. It was presented to him and his wife by Meharry students, alumni, and trustees. The residence still stands today and has been used as a parsonage for Seay-Hubbard Methodist Church.

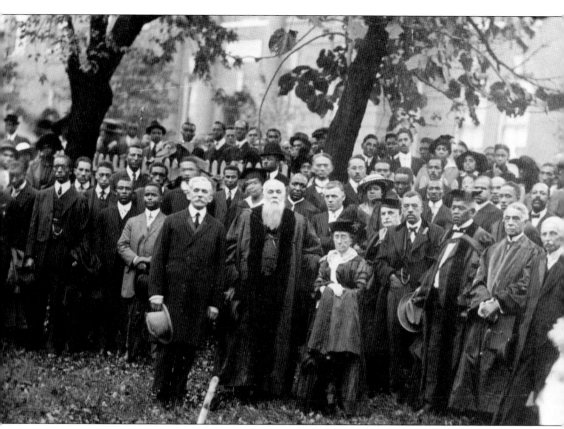

This photograph of the ground breaking for Anderson Anatomical Hall is the background on the cover of this book. Pictured are many Meharry faculty, students, and dignitaries. At center is a rare picture of Dr. Hubbard and his wife.

Two

PRES. JOHN MULLOWNEY
1921–1938

On February 1, 1921, John James Mullowney, MD, at age 44, succeeded G.W. Hubbard, becoming the second president of Meharry Medical College. Mullowney stated that his purpose in coming to Meharry was "to secure close harmony and cooperation among all races, to the end that the nation might be brought to its highest possible state of development." Under his administration, research and hospital facilities were expanded. Construction began in 1930, and at the beginning of the fall term of 1931, Meharry Medical College occupied its present location in north Nashville.

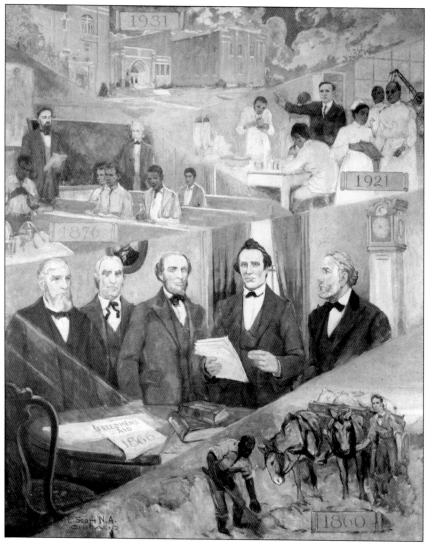

This mural is William Edouard Scott's oil on canvas painting of the history of Meharry in 1938. Scott was a preeminent African American muralist and illustrator born in 1884. By the 1930s, his reputation for mural paintings was well known. He had a penchant for painting murals of schools, settings that favored historical imagery. The central image is a group portrait of the Meharry brothers, the five white men standing before a desk bearing a document that names the Freedmen's Aid Society. The year 1866 references the passing of the Fourteenth Amendment. The 1931 inscription at top denotes the new Meharry campus. At upper left are Hubbard and Sneed instructing the first students. The 1921 inset is of Mullowney lecturing to a class the year he became president of Meharry. At lower right, Scott shows the incident that inspired Samuel Meharry's gift, the salt wagon legend. The mural, which stands more than seven feet tall, remains at Meharry and hangs in the original lobby of the hospital built in 1931. It was painted on the occasion of Mullowney's retirement after 17 years as president. Mullowney took credit for the idea of celebrating Meharry's history in an oil painting. The painting was commissioned by Maurice E. Hebert, a 1923 School of Dentistry graduate from Meharry. Dr. Hebert was the first black periodontist in the Chicago area.

By 1921, Hubbard Hospital was open year-round, and the number of faculty members increased. Outpatient departments were established and were located in the basement of the hospital. Two large laboratories were added to the hospital, one for physiology and the other for pathology and bacteriology. The hospital was remodeled and rearranged so that its capacity was 125 beds.

Meharry Medical College
With
Departments of Medicine, Dentistry, Pharmacy and Nurse-Training
NASHVILLE, TENNESSEE

MEHARRY MEDICAL COLLEGE,
ADMINISTRATION BUILDING

Catalogue of 1920-1921—Announcement
for 1921-1922

LIST OF STUDENTS, DENTAL DEPARTMENT

GRADUATING CLASS

Allen, Hord	Paris, Ky.
Allen, John Wesley	Griffin, Ga.
Alexander, Paul, A. B.	New Yory City, N. Y.
Alexander, Silas, A. B.	New York City, N. Y.
Askew, Edgar F. (May 11, 1923)	Norfolk, Va.
Brown, Delana Archie	Freeman, W. Va.
Brown, Walker D.	Newman, Ga.
Bullock, Joseph Moses	Bricks, N. C.
Bell, James Allen	Elberton, Ga.
Bledsoe, Thaddeus Cornelius, Jr.	Tyler, Texas.
Blue, Thomas Bernard	Farmville, Va.
Bundy, Niles Graham	Yoakum, Texas.
Boston, A. V.	Oveido, Fla.
Best, Thomas Henry, Jr.	Allendale, S. C.
Cuthbert, William McKinley	Jacksonville, Fla.
Cummings, Elizabeth Ardelle	Montrose, Ga.
Claiborne, Daniel Lorenza	Johnson City, Tenn.
Cherry, George Thomas	Ellenton, S. C.
Coble, Benjamin Franklin	Pulaski, Tenn.
Cochran, John Herman Davis	Pelham, Ga.
Chumm, Walter Dorian, B. A.	Atlanta, Ga.
Canady, Eugene Cicero, B. A.	Oxford, N. C.
Craig, Henry Charles	Birmingham, Ala.
Davis, Irby D., A. B.	Sumter, S. C.
Dannings, Robert Milton	Mangham, La.
Daniel, Ormond Holt	Longview, Texas.
Dennie, George Clinton	Columbia, S. C.
Dickson, Elias Leonard	Marshall, Texas.
Davis, Vivian Ray, A. B.	Salisbury, N. C.
DeGose, Edward H.	Gainsville, Fla.
Edwards, William Andrews	Birmingham, Ala.
Edwards, John Williams	Vicksburg, Miss.
Ellis, F. Milton	Kingstown, St. Vincent, B. W. I.
Foster, Percy Duke	Houston, Texas.
Fears, Willie Alfred	Farmville, Va.
Francis, Eddie Lee	Tyler, Texas.
Freeman, Sewell Cornelius, A. B.	Atlanta, Ga.
Gaskin, Woolridge D.	British Guina, S. A.
Grant, Alvin	Bainbridge, Ga.
Harrison, Charles Royal	Petersburg, Va.
Harrington, Hood Grady	Richmond, Va.
Hebert, Maurice Rufus	Beaumont, Texas.
Hallman, Legare Hannibal	Leeville, S. C.
Humphries, Lloyd Glasgow	Gaffney, S. C.
Howard, Edward Cuny	Mounds, Ill.
Heartwell, Joshua Lightfoot, A. B.	Petersburg, Va.
Johnson, Solomon E.	Chicago, Ill.
Jones, Charles Connelly	Institute, W. Va.
Jackson, DeForrest Carroll	Jackson, Miss.
Johnson, David Freeman	Paris, Ky.
Locke, Alonzo	Cairo, Ill.

In 1923, Meharry opened an additional dispensary and dental operatory in north Nashville. As a result, people in all sections of Nashville were within a short distance of medical attention. The class of 1923 included dentists who provided services to this new initiative.

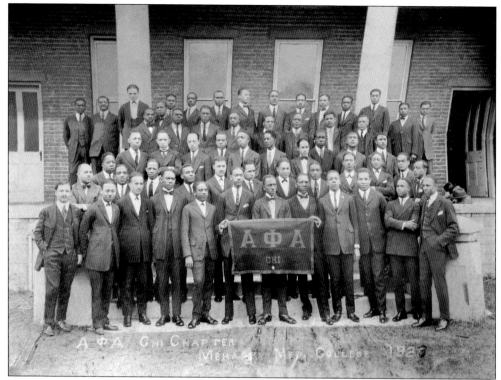

Alpha Phi Alpha was the first intercollegiate Greek-letter fraternity established for African American men. It was founded at Cornell University by seven men who recognized the need for a strong bond of brotherhood among African descendants in this country. The Meharry chapter is one of several established at other colleges and universities, many of them historically black institutions. Pictured is the Alpha Phi Alpha chapter at Meharry in 1923.

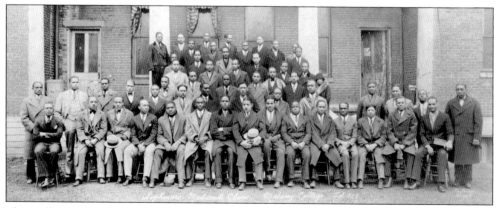

The college was given an "A" classification by the Council of Medical Education and Hospitals of the American Medical Association in 1923. This meant that its graduates could practice in 17 states that previously were closed to them. Pictured is the 1929 School of Medicine class.

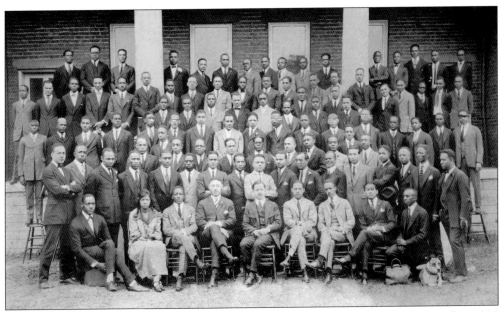

The dental infirmary was located in the Dental Dispensary, which was completed in 1923 on the west side of the Dental Hall. The dental infirmary occupied 5,829 square feet, with four accessory rooms and 63 chairs in active use. This group of dental students was the first to utilize the infirmary. Dr. Maurice Hebert, donor of the Meharry mural, was a member of this class. Pictured is the class of 1923 at the School of Dentistry.

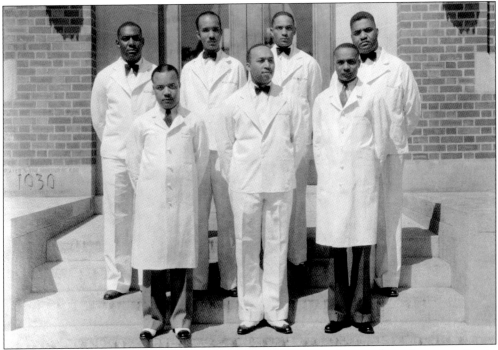

In the Department of Preventive Medicine, seniors devoted several weeks to studies in public health. They visited the Nashville health department, analyzed milk and water samples, and examined the vital statistics of the city.

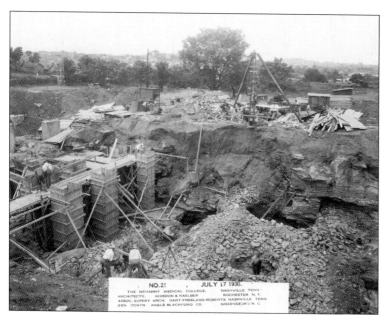

By 1923, Meharry's expansion and growth of its plant and facilities made it imperative that a completely new campus be built. Based on a 1928 land survey, it was decided to build on a spacious site. Land was purchased in north Nashville across from Fisk University, and the new 22-acre campus was completed in 1931.

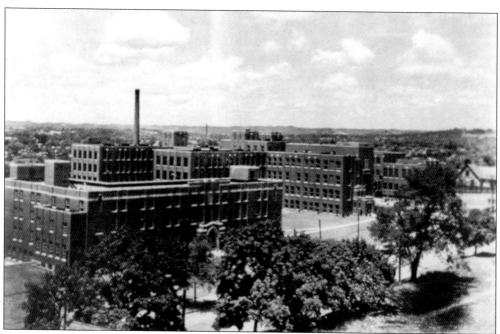

In February 1928, the Meharry Board of Trustees formally asked the General Education Board for funds to provide adequate and modern facilities. The General Education Board gave $1.5 million toward the cost of a new campus. Large amounts were also given by George Eastman of the Kodak Corporation, by the Julius Rosenwald Fund, and by the Edward Harkness Foundation. The trustees purchased six acres on Eighteenth Avenue, across the street from Fisk University. By fall 1931, Meharry occupied its new quarters, three modern brick buildings. Pictured is the 1931 hospital.

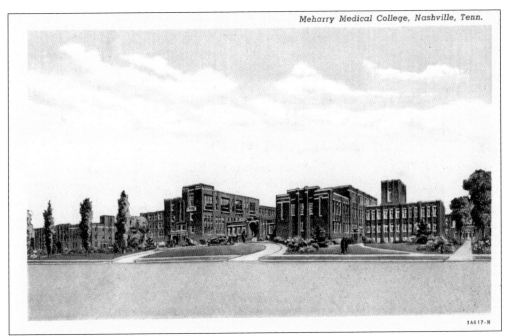

Meharry Medical College, Nashville, Tenn.

1A617-N

This vintage postcard gives another view of the hospital. The main building housed virtually the entire college and hospital, including the Schools of Medicine, Dentistry, Pharmacy, and Nursing.

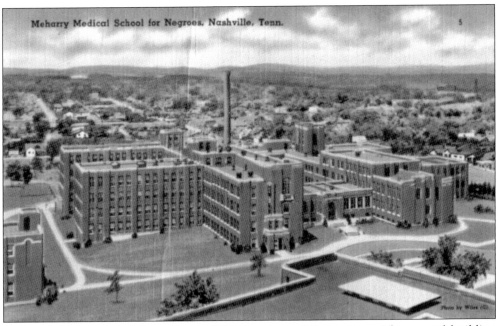

Meharry Medical School for Negroes, Nashville, Tenn.

Another vintage postcard provides a different view of the campus. The second building was a dormitory for nursing students and the third, a power plant. Attached to the main building was an auditorium and the Public Health Lecture Hall.

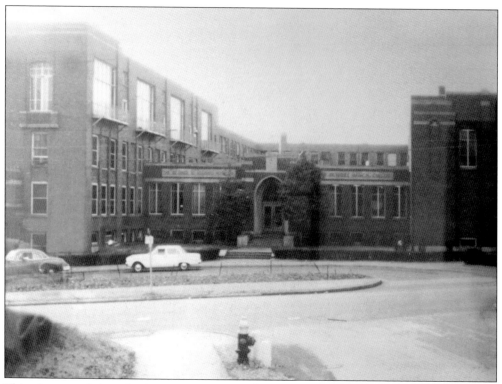

This photograph is a classic scene in 1931 in front of the new hospital. This faded view of the hospital is identifiable to most Nashvillians.

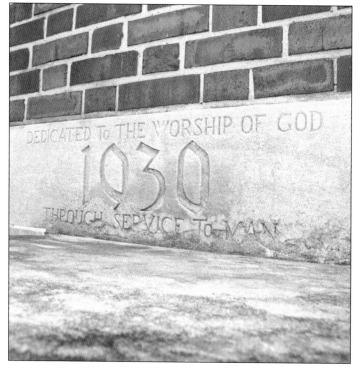

A cornerstone is literally a stone at the corner of a building. A cornerstone also has three distinct characteristics distinguishing it from the other stones used in construction: building orientation, history, and celebration. This 1930 Meharry cornerstone not only includes the date the building was constructed, but also includes the motto of the college, "Dedicated to the worship of God through service to man."

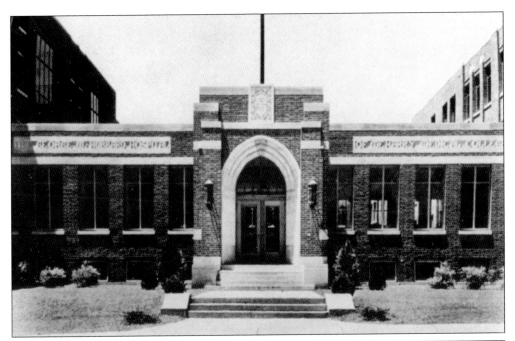

Carved in stone on the entrance
of the building is the inscription
"George W. Hubbard Hospital of
Meharry Medical College." This
entrance has become an iconic
historic site in the city of Nashville.

This photograph of the medical
school entrance shows the
unique architecture used in the
construction of the 1931 Meharry
campus. Several entrances have
carved stones noting names
of areas.

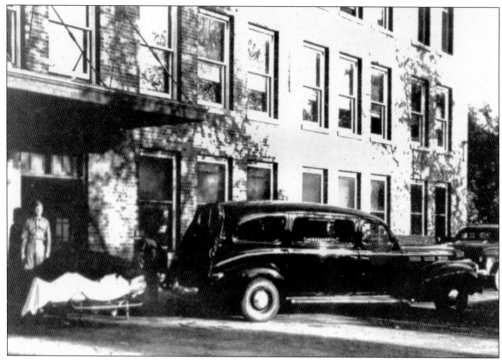

This 1930 photograph of the emergency room entrance of Meharry hospital is poignant, as a solder stands waiting to meet the wounded.

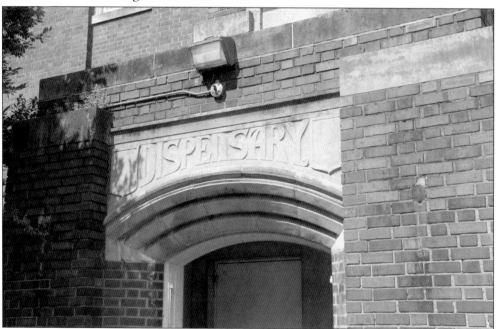

The outpatient department had its own entrance in the main building. Above its entrance, "Dispensary" was carved in stone. Obstetrical and pediatric cases; diseases of the eye, ear, nose, and throat; and genitourinary ailments were received and treated there on a 'round the clock' basis.

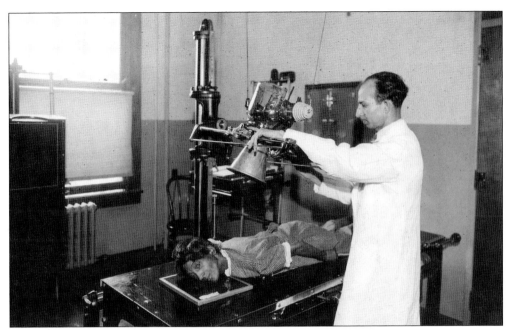

This is an early photograph of X-ray equipment being used on a patient. Also added to the hospital were more laboratories, diet kitchens, a morgue and autopsy room, and two more operating and delivery rooms.

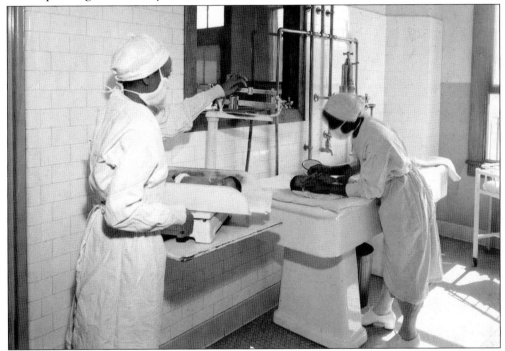

When Meharry relocated to north Nashville, the number of pediatrics patients gradually increased, and the service grew in proportion. Meharry initiated the fight for improved health among mothers and children by establishing the first prenatal clinic for black women in the South.

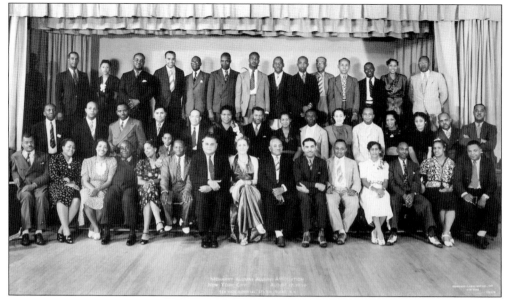

The alumni of Meharry have been active in the life of the college since the first graduation. Meharry graduates can be found in every state in the nation and multiple countries. This is a photograph of the New York Alumni Association at a gathering in 1930.

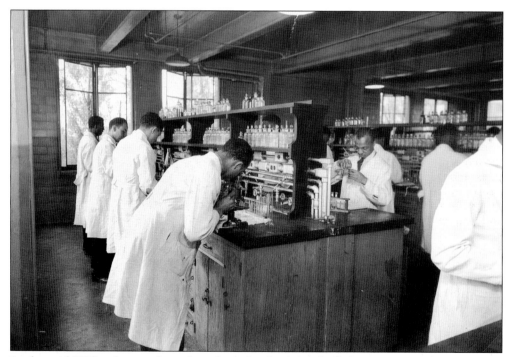

In the mid-1930s, the number of students in the School of Pharmacy was dwindling. As early as 1935, administration and alumni pleaded for applicants.

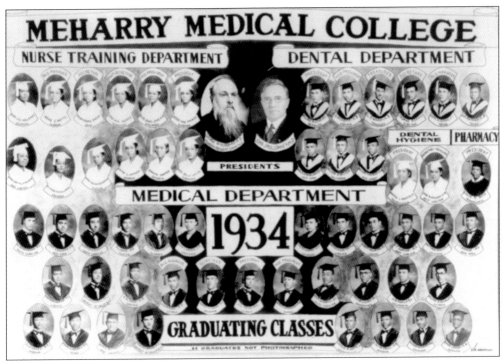

MEHARRY MEDICAL COLLEGE

NURSE TRAINING DEPARTMENT DENTAL DEPARTMENT

DENTAL HYGIENE | PHARMACY

PRESIDENTS

MEDICAL DEPARTMENT

1934

GRADUATING CLASSES

This composite photograph of the class of 1934 is indicative of the number of graduates per department. Medicine consistently had the largest class. Nursing and dentistry students comprise the second-largest group of graduates. The School of Pharmacy had only one graduate pictured.

Meharry was credited with bringing down the mortality rates among black people in the region. To widen and deepen the health services Meharry offered as an institution, it provided opportunities for its students to study those diseases that were especially prevalent among black people.

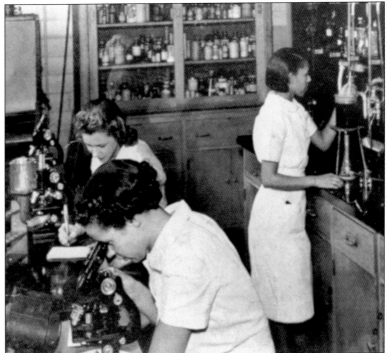

Dr. Hastings Kamuzu Banda graduated from Meharry's School of Medicine in 1937 and went to Scotland for postgraduate study. He then set up the first of several medical practices in England. Later in life, Dr. Banda returned to Malawi and became the president of the Republic of Malawi.

This is a photograph of one of many operations that occurred in Hubbard Hospital. Being a teaching hospital, the operating room normally had students in the background, nurses in training, and numerous physician attendees.

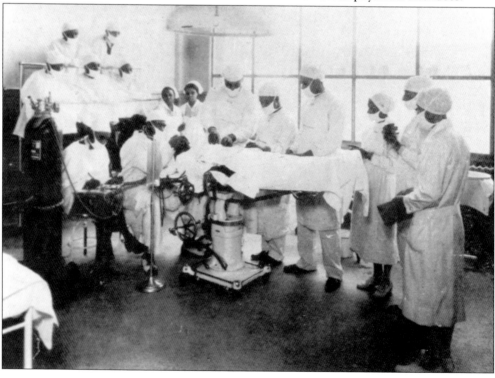

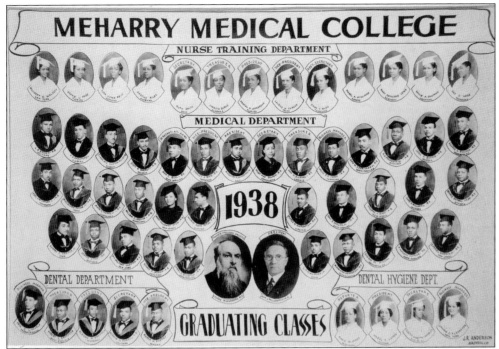

MEHARRY MEDICAL COLLEGE

NURSE TRAINING DEPARTMENT

MEDICAL DEPARTMENT

1938

DENTAL DEPARTMENT

DENTAL HYGIENE DEPT.

GRADUATING CLASSES

J.R. ANDERSON
KNOXVILLE

Graduates of the pharmacy department are missing from this composite photograph of the 1938 class of all schools. During the Great Depression, the School of Pharmacy began to experience low numbers of applicants. With only one qualified applicant, the School of Pharmacy did not offer courses in the fall of 1937. In 1938, the department closed due to a lack of enrollment.

At the height of the Depression, 61 black students were enrolled in dental schools throughout the nation. Enrollment in dental studies at Meharry declined so sharply that the department was threatened with closure. Pictured is the 1939–1940 dental class listing.

SCHOOL OF DENTISTRY 29

FRESHMAN DENTAL CLASS
1939-40

Alexander, Royal Clarke_____Orange, New Jersey
Allen, William Henry, A.B., Tougaloo College, 1938____Yazoo City, Mississippi
*Archibald, Joel P., A.B., Morgan College, 1930_____New York, New York
Burnside, Jackson L., B.S., Tuskegee Institute, 1939_____Nassau, N.P., Bahamas
Butler, Ralph E., B.S., Tennessee A. & I. State College, 1939_Indianapolis, Indiana
Carter, Ulysses Trusty, B.S., Rhode Island State College, 1939_East Providence, R.I.
Cartledge, James_____Augusta, Georgia
Chapman, William T., B.S., Knoxville College, 1939_____Brunswick, Georgia
Evans, Frank A., B.S., Shaw University, 1929_____Asheville, North Carolina
Gamble, James E._____Camden, South Carolina
Hogan, Clarence R._____Miami, Florida
Lewis, Granville Robert, A.B., Talladega College, 1938_____Little Rock, Arkansas
Sheppard, Freeman A., A.B., Wiley College, 1938_____Waco, Texas
West, Alexander Waymon, A.B., Fisk University, 1939_____Montgomery, Alabama
White, Kathryn Lee, A.B., Fisk University, 1937_____Nashville, Tennessee
Williams, Edward Butler_____Everett, Massachusetts
Wray, Kenneth Neil_____Georgetown, Demerara, British Guiana, S.A.

SOPHOMORE DENTAL CLASS
1939-40

Buford, Charles D._____Danville, Illinois
Burke, Lemuel Murvyn, A.B., Lincoln Uni. (Pa.), 1936_____Brooklyn, New York
Caldwell, Harlowe E., B.S., Claflin College, 1935_____Orangeburg, South Carolina
Carline, William Relph, A.B., Wiley College, 1933_____Lake Charles, Louisiana
Harper, William T., A.B., Lincoln Univ. (Pa.), 1938_____Orange, New Jersey
Massey, Edwill Orbert_____St. Louis, Missouri
Jackson, Andrew Leroy_____Detroit, Michigan
Jones, Mavis Naomi_____Canton, Mississippi
Mason, Eugene Gilford, A.B., Tougaloo College, 1938_____Chicago, Illinois
Ogilvie, Jasper G._____Washington, D.C.
Pitts, Williams H., A.B., Lincoln Univ. (Pa.)_____New Haven, Connecticut
Tyson, William Rufus_____New Haven, Connecticut
Williams, James Henry_____Selma, Alabama

JUNIOR DENTAL CLASS
1939-40

Alexander, William Hayes_____Boston, Massachusetts
Collins, Daniel Andrew, A.B., Paine College, 1936____Darlington, South Carolina
Eneas, Cleveland W., B.S., Tuskegee Institute, 1937_____Nassau, N.P., Bahamas
Jemerson, John William, A.B., Lincoln Univ. (Pa.), 1933_____Savannah, Georgia
Jenkins, Frederick G., B.S., Bishop College, 1936_____Waco, Texas
Keets, Nunley F., A.B., Lincoln Univ. (Pa.), 1932_____Washington, D.C.
Porter, Willem E.A._____Memphis, Tennessee
Rodgers, Gordon A., A.B., Talladega College, 1937_____Anniston, Alabama

SENIOR DENTAL CLASS
1939-40

The members of the senior dental class as listed below received the degree of Doctor of Dental Surgery on May 28, 1940.
Baskerville, Nathaniel G._____Stepney Depot, Connecticut
†Bell, William Richard, A.B., Morehouse College, 1929_____McKenzie
Coleman, Rossi Louis_____Coden, Alabama
Pinder, John Thomas, B.S., Wilberforce University, 1936_____Detroit, Michigan
Williams, James B., A.B., Wiley College, 1929_____Marshall, Texas

†With Honor

POSTGRADUATE IN DENTISTRY
JUNE 3-15, 1940

Booth, Sandy D., D.D.S. 1928_____Springfield, Illinois
Keith, Theodore Howard, D.D.S. 1921_____Blytheville, Arkansas

INTERNSHIP APPOINTMENTS OF THE SENIOR DENTAL CLASS
FOR 1940-1941

Coleman, Rossi Louis_____Forsyth Dental Infirmary, Boston, Mass.
Pinder, John Thomas___Murray & Leonie Guggenheim Dental Clinic, New York City

In 1938, the School of Pharmacy was forced to close because of low enrollment and college finances. The space was taken over by the School of Medicine.

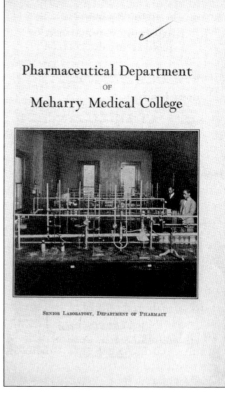

Pharmaceutical Department
OF
Meharry Medical College

SENIOR LABORATORY, DEPARTMENT OF PHARMACY

The School of Pharmacy opened its doors in October 1889 in the newly constructed Meharry Dental Building on the south Nashville campus. Throughout its 49-year history, the school trained more than 600 students.

Dr. Matthew Walker was one of Meharry Medical College's most distinguished graduates. He had been a prominent figure on the Meharry scene since 1934, when he earned his doctor of medicine degree with honors. Following an internship at Hubbard Hospital, he served as a resident physician in surgery and gynecology at Hubbard for three years, from 1935 to 1938. Thus, while a resident, he served as an instructor in anatomy from 1935 to 1938 and as an instructor in surgery; gynecology; orthopedics; anesthesia; and eye, ear, nose, and throat from 1936 to 1938. Returning to Meharry in 1939, he was appointed assistant professor of surgery and gynecology. In 1947, Dr. Walker directed the surgical service at Taborian Hospital in Mound Bayou, Mississippi. He was instrumental in the success of the program by ensuring the hospital would be staffed with qualified house staff and surgical students from Meharry on a rotating basis. The agreement contained a clause permitting other departments at Meharry to send students and staff to Taborian. He also formed the Matthew Walker Surgical Society and the Matthew Walker Community Health Center.

Dr. Daniel T. Rolfe earned his doctor of medicine degree from Meharry in 1927 with highest honors and began his faculty career the following fall as an instructor in gross anatomy while an intern at Hubbard Hospital. After postgraduate study in physiology at the University of Chicago from 1928 to 1930, he returned to Meharry to serve as professor of physiology. In 1938, Dr. Rolfe became executive secretary of the Meharry Alumni Association. Under his leadership, $200,000 was raised toward the construction of Alumni Hall. In 1944, Dr. Rolfe was named chairman of the Department of Physiology and Pharmacology.

Three

PRES. EDWARD L. TURNER 1938–1944

Dr. Edward L. Turner, at the age of 37, assumed the position of the third president of Meharry Medical College in 1938. Dr. Turner had been brought to Meharry in 1936 to help implement President Mullowney's plan to begin preparing capable black faculty to succeed aging department chairs. By the end of the 1940s, care in student selection and the emphasis laid upon faculty excellence produced a spectacular increase of Meharry graduates passing the state and national medical licensing boards. Under the six-year leadership of Dr. Edward Turner, much was accomplished at Meharry; however, he resigned in 1944.

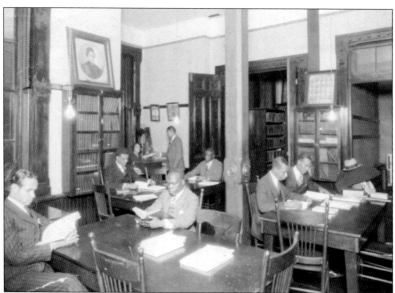

The Meharry Library had previously been on the campus of Fisk University at its Milo Cravath Library. President Turner moved the library from Fisk to the Meharry campus in 1939.

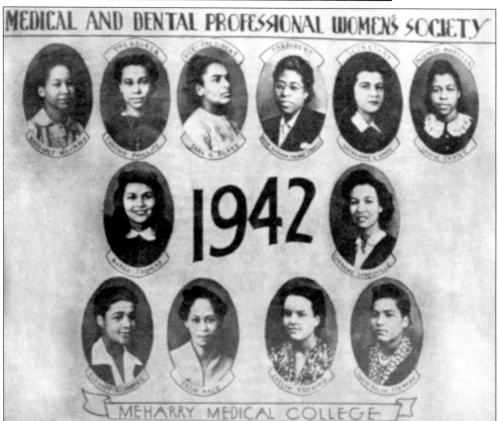

Realizing the importance of forming a society to meet and discuss scientific questions pertaining to the allied profession, the women of the class of 1942 organized themselves into an association for the purpose of keeping informed of the latest and most scientific methods in the healing art.

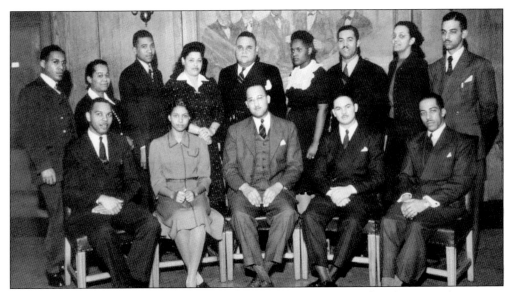

In the private office of Dr. R.F. Boyd, a group of not more than 24 Meharry graduates met for the purpose of organizing a Meharry Alumni Association. Little did these pioneers realize that their group was actually the embryo of a developing organizational giant. From the day of matriculation, students were considered a junior member of the medical fraternity and a participant in a profession. Such campus organizations as the Pre-Alumni Association reflected the increasing self-consciousness of Meharry students. This photograph is of the 1943 Pre-Alumni Association.

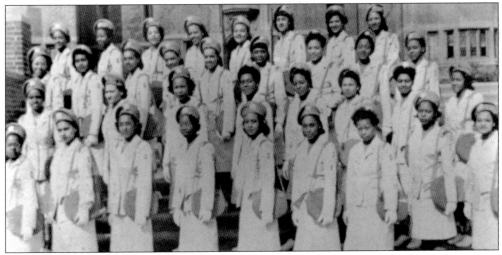

During World War II, Meharrians were called to serve once again. The US Public Health Service for the US Cadet Nurse Corps was established at Meharry School of Nursing in 1943. Any nurse enrolled in the School of Nursing was eligible to join the corps. The senior cadet period was spent in the home hospital, in Army or Navy hospitals, or in an approved specialized service such as public health or a psychiatric hospital. At the end of senior cadet training, cadets were eligible for gradation from the Meharry School of Nursing. A member of the corps signed a statement that she intended to remain in essential nursing service for the duration of the war. Pictured are US Cadet Nurse Corps members who served in World War II.

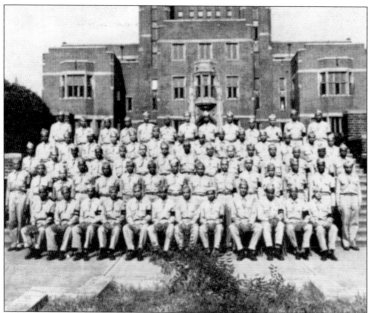

Meharry students paused their careers in attending Meharry to join the armed forces during World War II. These students and physicians were ready to work and fight for their country, but at the same time, they demanded an end to the discrimination against them in their own country. Pictured are Meharry soldiers on the steps of Cravath Library at Fisk University.

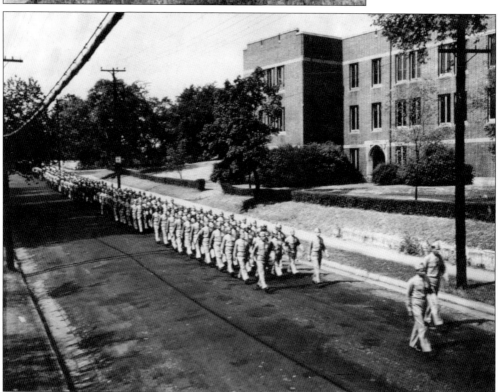

This image illustrates the number of Meharrians who participated in World War II. The majority of these soldiers served in a medical capacity during the war. They served with distinction, made valuable contributions to the war effort, and earned well-deserved praise and commendations for their sacrifices. Pictured are the troops representing Meharry marching along the campus of Fisk and Meharry.

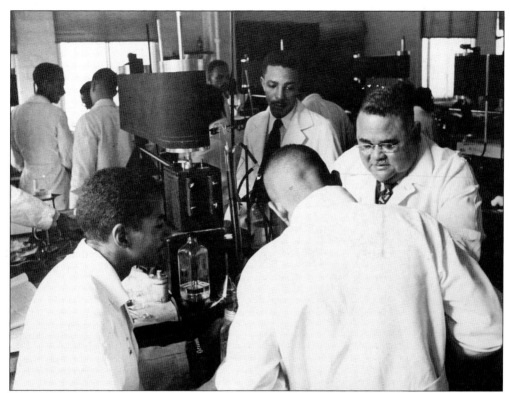

Dr. Daniel T. Rolfe was an important
figure in the progress of Meharry
Medical College. He was not only
a leader in research, but under
his guidance, the Meharry Alumni
Association became a rallying point
for the college's graduates and their
financial support of Meharry. Pictured is
Dr. Rolfe in research with students.

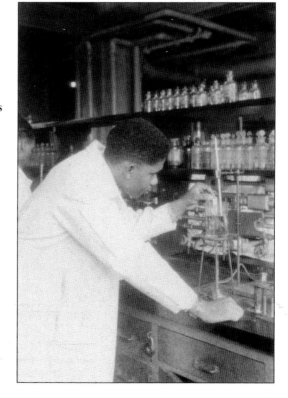

In 1940, under the presidency of Dr.
Turner, Meharry organized the School
of Clinical Laboratory Technology to
educate laboratory technicians. The
school was approved by the Council
on Medical Education of the American
Medical Association.

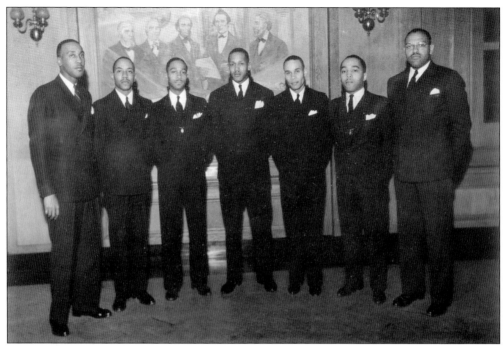

The Meharry Singers were equally divided between medical and dental students. The young men freely offered their services to the school and community for relaxation in song and harmony.

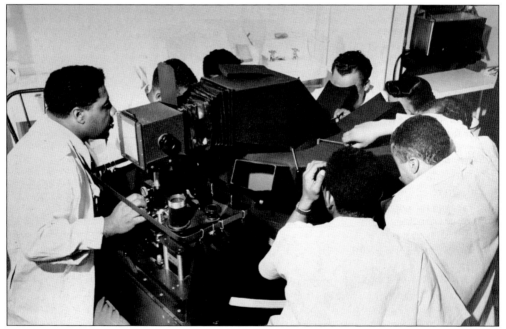

In 1937, a tumor clinic was established at Hubbard Hospital under the Department of Radiology. A tumor committee was formed with representatives from surgery, pathology, internal medicine, dentistry, and radiology. This was the first tumor clinic in Nashville to be recognized by the American College of Surgeons.

Four

PRES. M. DON CLAWSON
1945–1950

Dr. Mation Don Clawson
was elected the fourth
president of Meharry and
the first dentist in US
history to be appointed
president of a medical
school. Dr. Clawson's goal
was to make Meharry a
center for undergraduate
and graduate professional
training in medicine,
dentistry, nursing, and
medical technology.
Success was reflected in
a number of major events
in 1945, such as student
enrollment attaining a 200
percent increase over its
previous three years and
the School of Dentistry
being granted full approval
by the American Dental
Association. From 1950
to 1952, Meharry was
under the leadership of an
interim committee.

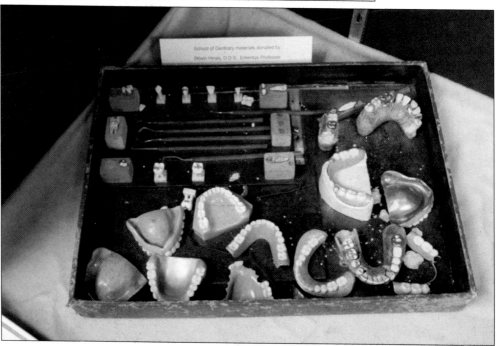

Meharry Medical College School of Dentistry
Class of 1945

The class of 1945 witnessed an increase in the enrollment of the School of Dentistry. Dr. Clawson was instrumental in obtaining necessary financial support for the school.

In October 1945, Omicron Kappa Upsilon, the national dental honorary society, established a chapter at Meharry. The school initially applied for inclusion in 1943, and the organization denied approval. A formal letter of protest was sent to the organization, and Meharry resubmitted a second petition for consideration. When granted membership in 1945, this marked the first time that a school for African American students was awarded a chapter in dentistry's national honor society. Such recognition enhanced the stature of the school among its peers.

In 1947, Dr. E. Perry Crump (MD, 1941) returned to Meharry with a certification in pediatrics. In 1950, he was appointed chairman of the Department of Pediatrics. Dr. Crump was known as one of the outstanding researchers in the area of premature births and mental retardation.

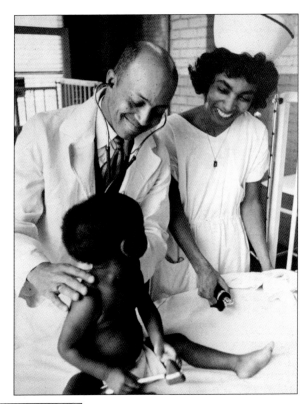

Before 1948, a black baby born prematurely in the mid-South had minimal chances to reach the age of one. In that year, Meharry began a pediatric premature care program to boost the survival chances of such infants. Those whose parents lived within 85 miles of Nashville were picked up in the college's specially equipped ambulance. Once the babies were out of danger, Meharry pediatricians taught the parents how to continue to care for their special needs.

During the war years, Meharry and the people of Mound Bayou, Mississippi, began a venture in medical education and service that was to endure and grow in significance. Taborian Hospital in Mound Bayou needed the skills of Meharrians, and the college required opportunities for its students and graduates to meet the licensing requirements of an internship. The two institutions were in a natural position to help each other. Dr. Matthew Walker is credited with developing the arrangement between Taborian Hospital and Meharry Medical College. Senior and junior surgical residents from Meharry served from four to six months each year at Taborian. As a result, Taborian Hospital was able to give competent surgical care to thousands of patients from the Delta region. This alliance became a model for rural health care throughout the nation. Pictured are residents of the Mound Bayou community.

Dr. Dorothy Lavenia Brown was one of Meharry's favorite daughters. She studied medicine and graduated from Meharry in 1948. Following graduation, she interned at Harlem Hospital in New York and returned to Meharry for a surgical residency under Dr. Matthew Walker. Dr. Brown worked through a five-year residency at Meharry to become assistant professor of surgery in 1955. In her personal life, the single Brown legally adopted a daughter of a young unmarried patient in 1956. She was the first black female surgeon to practice in the Southeast, and became the first black woman elected to the Tennessee General Assembly in 1966. She received many honors and awards, including the prestigious Horatio Alger Award in 1994. Among her many honors by her beloved Meharry was the naming of the Dorothy L. Brown Women's Residence Hall.

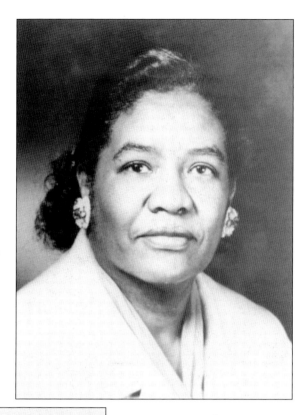

A L M A M A T E R

EMERY L. RANN '48 THEODORE R. STENT '48

Steadfast and strong
Majestic in her might,
Shining in glory
From her lofty height—
Our Alma Mater
Wreathed in beauty stands,
Guiding our lives,
Our rev'rence she commands.

Help all thy sons,
In serving mankind's needs,
To share thy love in
Doing noble deeds
With grateful praise
And lasting faithfulness.
O Meharry,
Guide us in our quest.

Two students in the class of 1948, Emer L. Rann and Theodore R. Stent, wrote the alma mater of Meharry Medical College.

From 1950 to 1952, Meharry was under the leadership of an interim committee. On the advice of President Clawson, the board of trustees designated five men to administer the affairs of the college until a new president could be selected. Dr. Robert Lambert was appointed chairman, and Dr. Harold West was appointed vice chairman. Other members of the committee were Dr. Hugh Morgan, Dr. Matthew Walker, and Dr. Amos Christie. Every week for the next two years, these men met to decide the future direction of the college. The interim committee presented a balanced budget in 1951, the first at Meharry in more than a decade. There were many accomplishments of the committee: an increase in the number of graduate students, expansions of Meharry's 20-year-old physical plant, a new residence hall for unmarried male students, and construction of Alumni Hall, which was renamed the Daniel T. Rolfe Alumni Student Center in honor of the contributions of Dr. Daniel T. Rolfe.

Five

PRES. HAROLD WEST
1952–1966

In 1952, Meharry reached a milestone by inaugurating its first black president, Dr. Harold D. West. Dr. West was recommended by his four colleagues on the interim committee. Two years' work on the interim committee gave Dr. West the experience in financial affairs that Meharry's president needed. West's administration years are considered the ones of expansion for Meharry Medical College. A drive to raise $20 million was initiated. A plan to acquire land adjacent to the campus for new construction was implemented. Dr. West's administration also featured expanding the curriculum, encouraging research, increasing the endowment, and working for improvements for the faculty and students.

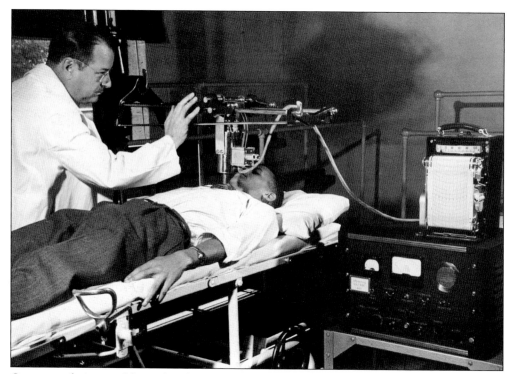

Grants made it possible to develop courses and research programs in crippling diseases, including cancer. The American Cancer Society assisted in funding cancer research. Pictured is a Meharry doctor in the mid-1950s utilizing new technology.

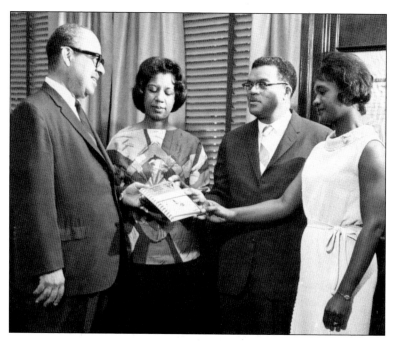

President West is pictured here presenting a book to Dr. Theodore Bolden, PhD (DDS, 1947). Dr. Bolden spearheaded research seminars in the School of Dentistry and guided the Student Oral Research Program.

Dr. West's administration took place during the tumultuous 1960s. Meharry students participated in the student protest movement. Pictured are students sitting at a lunch counter in Nashville, Tennessee.

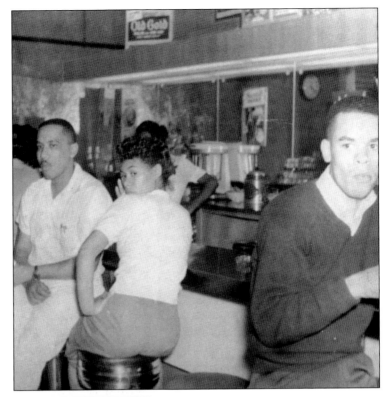

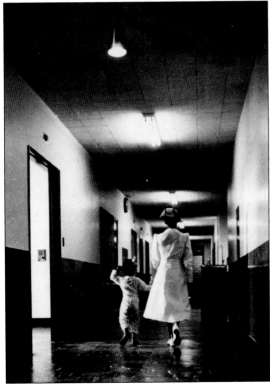

In 1958, when the National League for Nursing evaluated Meharry's nursing program, it noted the serious problem of faculty turnover and requested regular reports from the School of Nursing. By the spring of 1960, no substantial progress had been made. In September 1960, the board of trustees voted to close the School of Nursing. This iconic photograph shows a nurse walking down the hall of Hubbard Hospital holding the hand of a child.

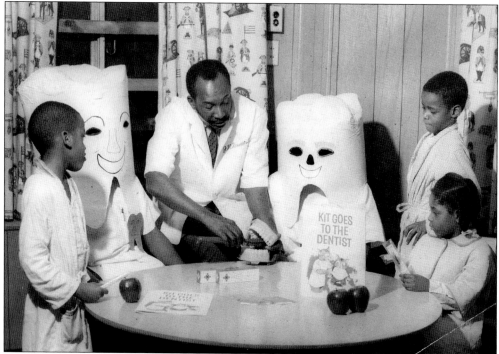

In 1962, Dr. James H. Brown assumed charge of the hospital's dental program. Three years later, dental students began receiving academic credit for their hospital work.

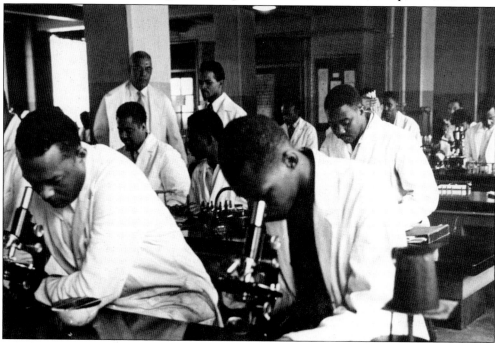

During this period, for the first time, money was becoming available to Meharry in significant amounts from the federal government. These public funds became the largest source of revenue to the college.

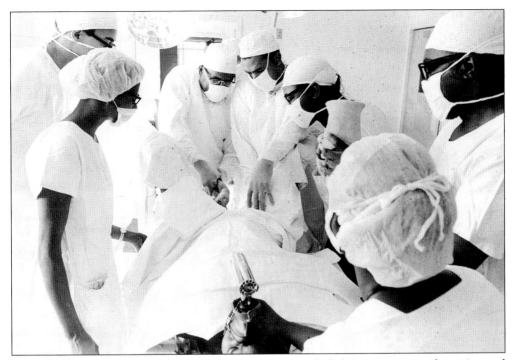

The highlight of a medical student's last year was a clerkship in surgery, obstetrics and gynecology, and pediatrics. Each of these clerkships were intensive, and students spent time observing surgical procedures.

A grant from the National Institutes of Health and contributions from private donors enabled Meharry to further research in the sciences. Pictured are Dr. Marion Zealey (left) and Dr. West.

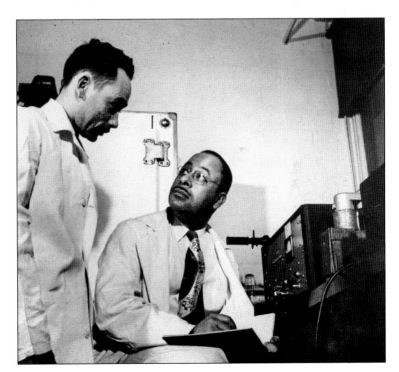

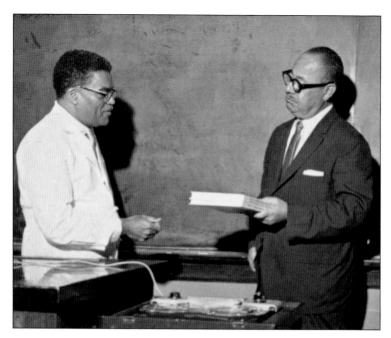

Dr. West always acknowledged that research was his first love. Along with his accomplishments as Meharry's president, research was one of his enduring achievements. Pictured are Dr. Bolden (left), one of the pioneers in the School of Dentistry, and Dr. West.

The Meharry classes of this period became more diverse. In 1957, three young white people presented credentials acceptable to Meharry's admission committee, and they were invited to enroll for the fall semester. After 1965, white students made up almost one-fifth of Meharry's first-year class. Pictured are white students graduating along with their classmates.

Dr. Charles W. Johnson, a Meharry alumnus and teacher who was himself a pioneer as a postdoctoral fellow, eventually became a leading figure in the expansion of the college's graduate programs. He was appointed chairman of the Department of Microbiology and was later appointed to the position of dean of graduate studies. Pictured is Dr. Johnson in a lab conducting one of many experiments.

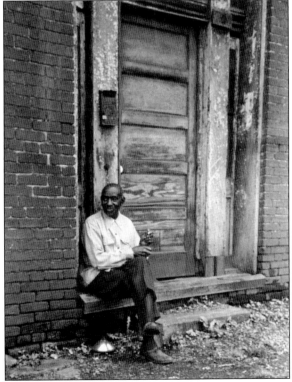

It was during the West administration that Meharry continued to reach out to the impoverished people of the Mound Bayou region. In 1966, Dr. West and his administration were approved to initiate their grant from the Office of Economic Opportunity that would benefit the indigent people of Mound Bayou as well as the poorer black Nashville community.

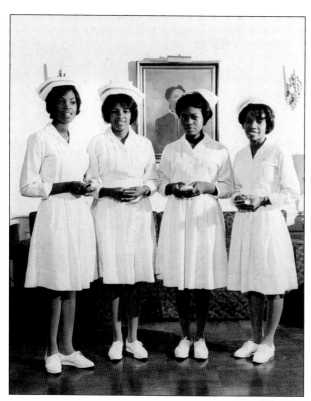

In 1960, the School of Nursing closed. Despite the efforts of President West, the college's mounting deficit had created a state of emergency. The last class from Meharry's School of Nursing graduated in 1962, thus ending one of Meharry's education traditions. Pictured are four nursing students.

By 1955, projects were being conducted in the general fields of nutrition, metabolism, radiobiology, radiation, therapeutics, immunology, and cancer.

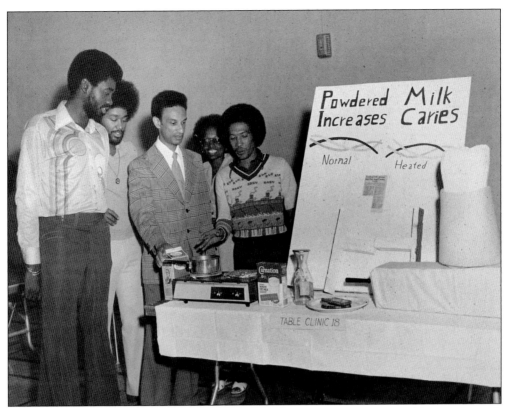

Beginning in 1956, Meharry sought to encourage research by undergraduates through an annual Student Research Day. The event is an opportunity for the entire Meharry community to get an overview of the research conducted by students. Thirty-nine papers were presented on the first occasion. The program is usually held on the last Wednesday in March and is highlighted by a special lecture given by an outstanding scientist. This tradition is still one of the more popular activities of student life.

Dr. West was active with alumni organizations from various cities. His encouragement of alumni giving played a significant role in funding building projects and other initiatives.

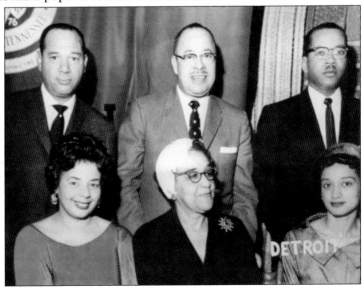

Preparing postwar graduates for changes in medicine was a goal of the West administration. Pictured is President West presenting a diploma to his son Harold D. West Jr.

Besides sharing monetary sacrifices with their husbands, faculty wives and daughters took an active part in the building and growth of the college. These women's organizations raised funds, hosted visitors to the campus, and sponsored workshops on community needs and health education.

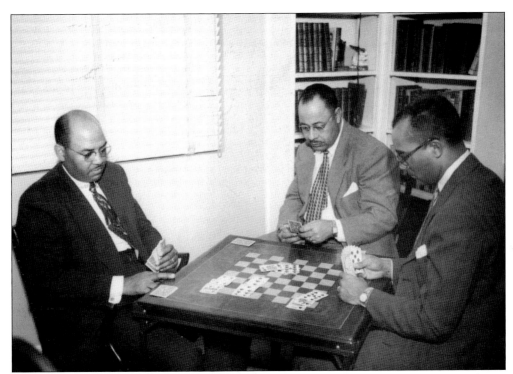

Dr. West is pictured taking a break from the challenges of his presidency by playing cards.

Dr. David Todd was a graduate of the Meharry class of 1956. He returned to Meharry as assistant professor of surgery and head of the Division of Thoracic and Cardiovascular Surgery. He later became the chief of the division. Dr. Todd was the first black cardiovascular surgeon in Nashville. He headed the team that performed the first open heart surgery at Meharry in 1972. Dr. Todd is one of Meharry's most well-known graduates.

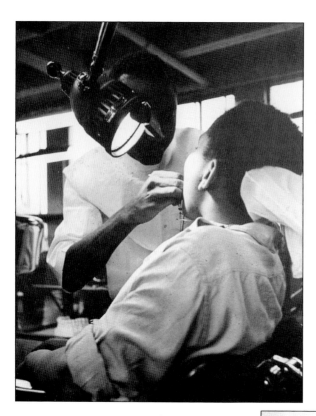

Beginning in 1953, a voluntary intern program for senior dental students was instituted at Hubbard Hospital. Meharry began making a dental examination part of the care of every patient admitted to Hubbard.

From 1966 to 1968, an interim committee was appointed by the board. Members were Dr. Robert Anderson, chairman; Dr. William Allen; John Sharp; and Dr. Lloyd C. Elam. Pictured here is the 1967 commencement cover.

MEHARRY MEDICAL COLLEGE

Ninety-Second

Commencement

Meharry Campus
Nashville, Tennessee

June 12, 1967

Six

PRES. LLOYD C. ELAM
1968–1981
PRES. RICHARD LESTER
1981–1982 (INTERIM)

On June 9, 1968, Dr. Lloyd C. Elam was selected as the sixth president of Meharry Medical College. The social changes of the 1960s had mandated the nation to improve the socioeconomic conditions of disadvantaged minorities. Under Dr. Elam's administration, Meharry instituted a comprehensive development program for the college. The 12 years of the Elam administration brought significant changes in the structure of the college. In February 1981, Dr. Lloyd Elam resigned and was named the first chancellor of the college.

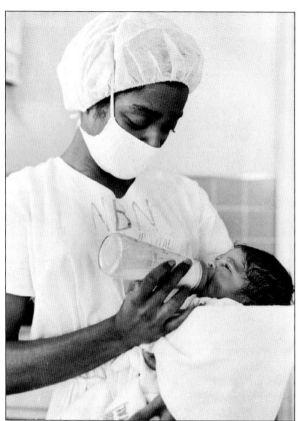

In 1968, Meharry opened the Comprehensive Children and Youth Center to treat patients from birth through the age of 18. By 1975, the center had enrolled some 6,935 children in north Nashville.

Built upon the theory of comprehensive care, the outpatient clinics placed emphasis upon the whole patient. This included the person's social history and present circumstances of life as well as the wide range of environmental influences that caused or complicated the person's difficulty. While the Outpatient Dialysis Center did not open until 1999, the idea of outpatient clinics was conceived in early administrations.

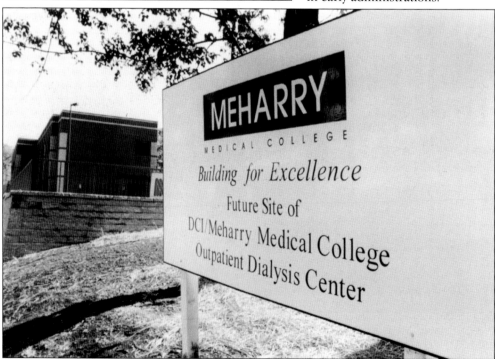

The Meharry Student-Faculty Towers was built in 1971. This was one of the first of many building projects during the Elam administration.

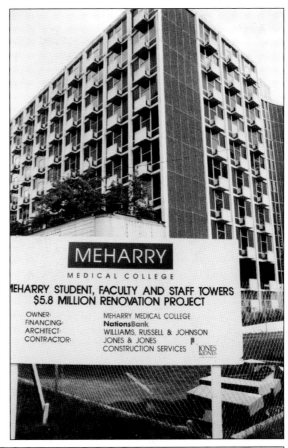

Pictured is an internal view of the Neighborhood Health Center, which opened in mid-1969. The goals were to provide comprehensive health services to residents of a low-income service area.

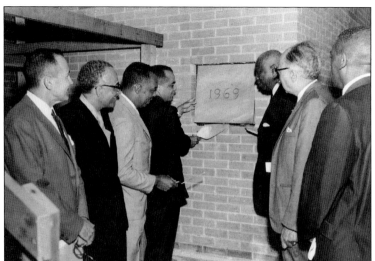

The 1969 commencement was celebrated with the dedication of the Matthew Walker Neighborhood Health Center. Pictured at center holding the stone are Dr. Matthew Walker (left) and Dr. Elam, along with other dignitaries.

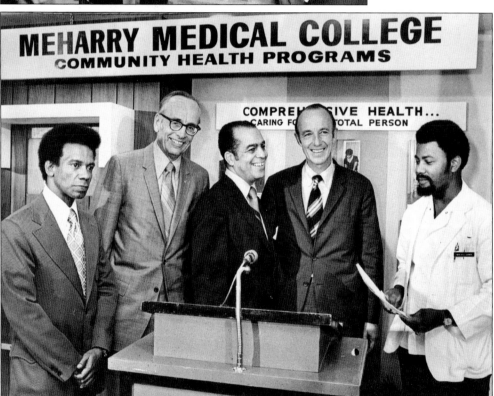

The Meharry Medical College Community Health Programs include health screening for the aged, cancer screening, visual screening, a screening program for mental retardation, preventive dentistry and health, comprehensive health care and youth services, the Regional Health Program, the Meharry Neighborhood Health Center, X-ray technology school, junior dental scientist programs, Head Start programs, Neighborhood Youth Corps, and the Mound Bayou Mississippi Project. Pictured are, from left to right, Dr. Ralph Hines; Victor Johnson; President Elam; Dr. David Rogers, president of the Robert Wood Johnson Foundation; and Mahlon Cannon, president of the Pre-Alumni Association.

Dr. Elam is shown enjoying a round of golf at the Duffers Golf Tournament. This was one of many fundraising activities initiated by Dr. Elam.

Dr. Elam is pictured on the steps of the iconic entrance of Hubbard Hospital with local members of the Masons and the Order of Eastern Stars. The organizations had gathered to present a donation to the college.

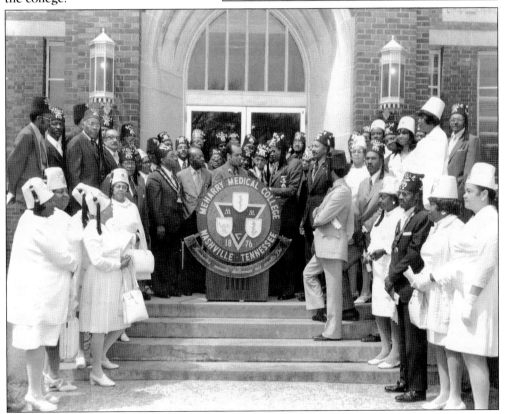

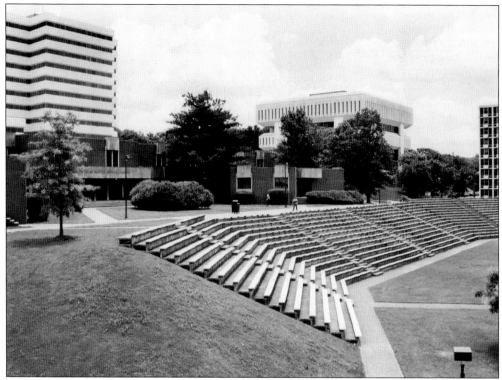

The amphitheater was built in 1975. The beautiful outdoor setting has been the site of numerous Meharry graduations. There were some 14 buildings erected under the Elam administration.

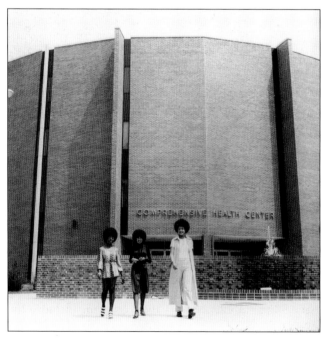

The Comprehensive Health Center was built in 1972. It was established to meet community health needs with comprehensive primary care instead of the episodic and fragmented treatment of the illness or injury of the moment, which the low-income patients of the area had been accustomed to at the specialty clinics. Dr. Elam was also the leader in orchestrating the organization of the Mental Health Center. He advocated a holistic approach in caring for patients who suffered from mental illness. Later in 1972, the Mental Health Center was named in his honor.

As a part of service to the community, the comprehensive health care program provided transportation to patients. Pictured are vehicles used to transport community participants.

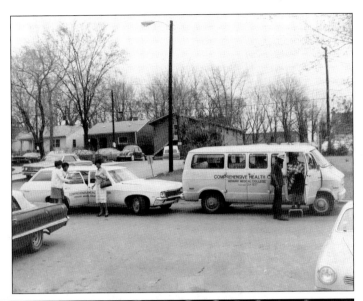

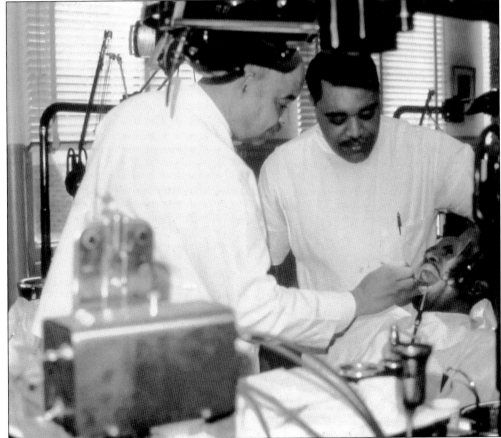

There were several research projects initiated in 1968. A health care evaluation, a cooperative study with the Tennessee Mid-South Regional Medical Program, included the epidemiology of various dental diseases.

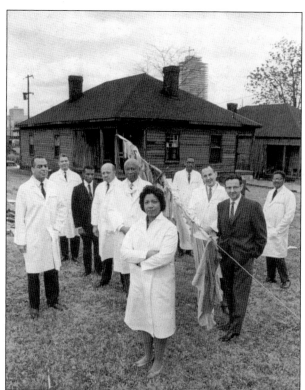

In a scene of urban poverty in a north Nashville neighborhood contrasting with a distant skyline showing urban progress, the Meharrians pictured here include President Elam, Dr. Matthew Walker, and other faculty and administrators.

The Elam administration began construction projects in 1969. This is the ground breaking of the George Russell Towers. Dr. Russell was a Meharry alumnus who became a member of the board of trustees and loyally served his alma mater. By 1976, major facilities were added to the campus and extensive renovations completed.

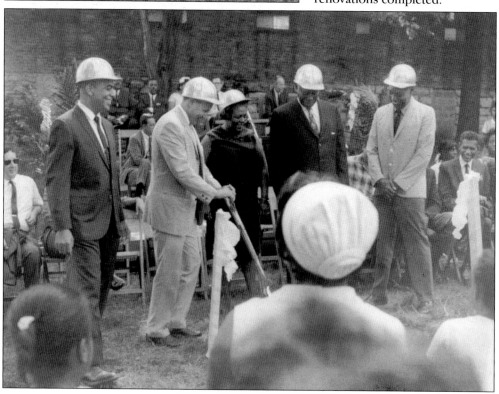

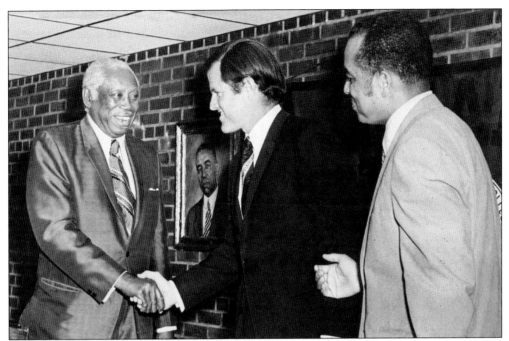

From left to right are Dr. Matthew Walker, Sen. Edward Kennedy, and Meharry president Lloyd Elam on campus in 1971.

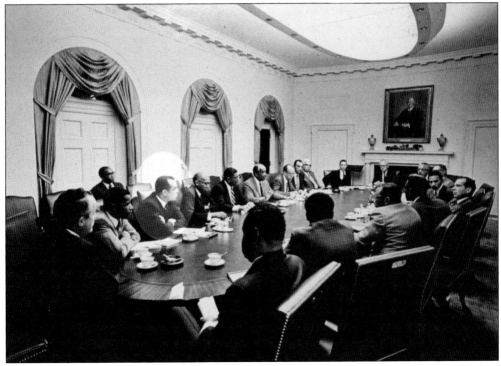

In 1970, President Elam was invited to the White House by Pres. Richard M. Nixon. Seated around the table are other presidents from historically black colleges and universities.

President Elam is presenting a diploma to Alphonso P. Johnson Jr., class of 1972. His father, Dr. Johnson Sr., was a graduate of the class of 1951.

President Elam is presenting a special award to Dean William Allen. Dr. Allen retired at the end of the 1970–1971 school year. A Meharry alumnus (class of 1943) and professor of prosthetic dentistry, Dr. Allen was named dean of the School of Dentistry in 1949.

This photograph was taken at a fundraising reception in New York. Pictured with Dr. Elam (left) is John F. McGillicuddy, chairman and president of Manufacturers Hanover Corporation. McGillicuddy led a campaign for $27 million for the college.

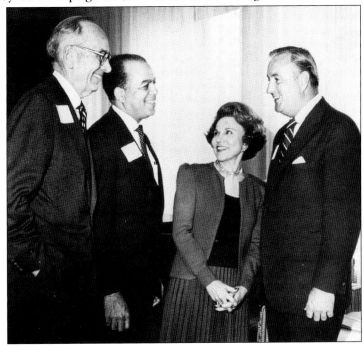

Others who spoke at the reception launching the national drive were, from left to right, Victor S. Johnson Jr., president of Aladdin Industries and chairman of Meharry's board of trustees; Dr. Elam, Meharry's chancellor; Ann Landers, a Meharry trustee; and John F. McGillicuddy, campaign chairman.

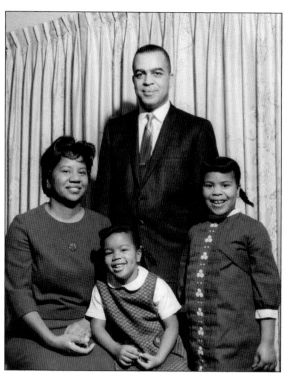

President Elam is pictured with his young family. Seated are his wife, Clara, and daughters Laura and Gloria.

The Office of Economic Opportunity was started during the presidency of Lyndon Johnson. The Economic Opportunity Act was passed, and community action programs were enacted. From left to right are Dr. Elam, Dr. Ralph Hines, Mayor Richard Fulton, and Leslie Falk.

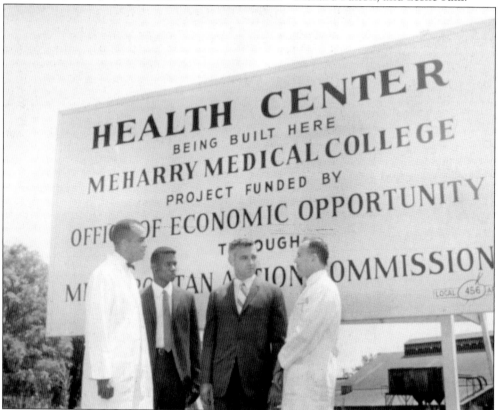

A revised, dynamic curriculum was a goal of President Elam. This included research in cardiovascular diseases. Meharry appeared poised to become a major research institution. Dr. Elam saw the need to expand the future of scientific work while honoring the college's first black president, Dr. Harold West. Dr. West had died in 1974, but the achievement of his life was as a distinguished research scientist. In dedicating the Harold D. West Basic Sciences Center, Elam noted that the building brought together all of the college's basic science departments—anatomy, biochemistry and nutrition, microbiology, pathology, pharmacology, and physiology. While committed to offering comprehensive care in a poor community, the college also had an opportunity to demonstrate that scientific rigor was not the whole of medicine, yet it could also affirm the importance of basic research.

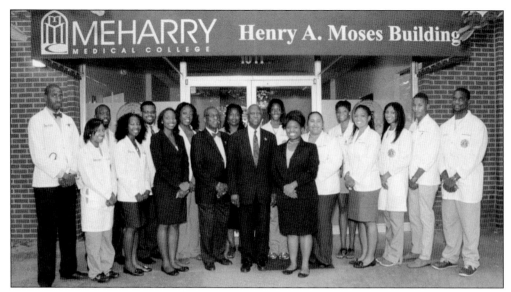

Dr. Henry A. Moses, PhD, came to Meharry as an assistant professor of biochemistry in 1964. In 1967, he became Meharry's first provost for internal affairs and chaired the centennial celebration of the college. The original Henry A. Moses Building was constructed in 1972 and named in honor of Dr. Moses for his unwavering devotion to Meharry Medical College. On Friday, November 1, 2013, Dr. Moses, now executive director of Meharry National Alumni Association Inc. and professor emeritus (biochemistry), was honored as the new Alumni Hall officially became Henry A. Moses, PhD Alumni Hall.

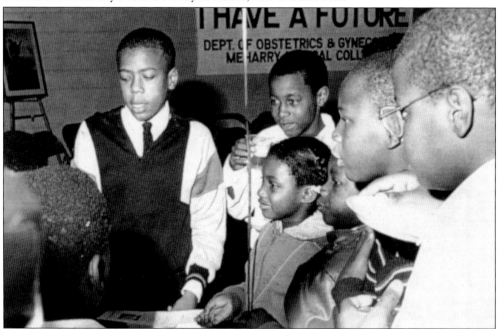

Established in 1980, the "I Have a Future" program targeted the major inner-city housing projects in Nashville, providing teenagers with alternatives to pregnancy, violence, and substance abuse. It was a program that showed teenagers that they had positive, worthwhile futures to work toward.

On April 6, 1973, the new S.S. Kresge Learning Resources Center was dedicated. It houses the central administration offices, including the president and the senior vice president for administration; vice president for academic affairs; vice president for business and finance; vice president for institutional advancement; general counsel; and the library.

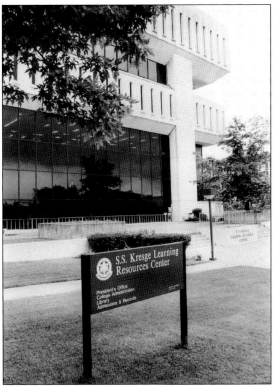

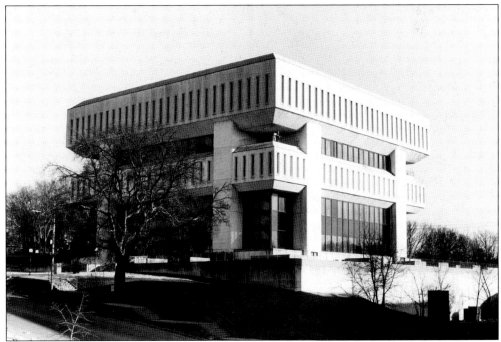

The Meharry Medical College Library and Archives are on the second, third, and fourth floors of the S.S. Kresge Learning Resources Center. The library plays a major role in supporting the instructional and research programs of the college.

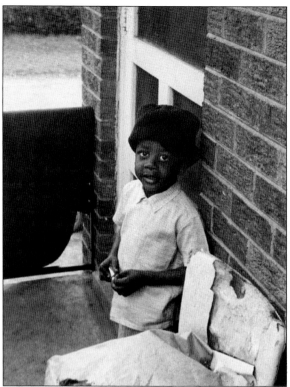

The Mound Bayou initiative continued to be a significant community outreach program of the college. Meharrians continued to serve this community in Mississippi. Eventually, a Mound Bayou Community Hospital was established with major assistance of Meharry's Dr. Matthew Walker. Pictured is a child of the Mound Bayou community.

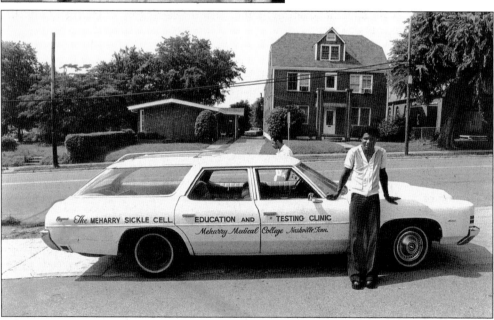

In 1972, the Comprehensive Sickle Cell Center was one of 10 sickle cell centers funded by the National Institutes of Health. The purpose of the center was to offer patient care, including genetic counseling and education, to conduct basic science and clinical research, and to train health and allied health professionals. Pictured is one of the vehicles used to transport sickle cell patients to the center.

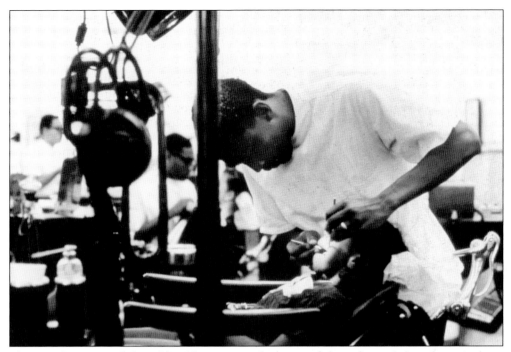

The social aspects of dental health were another part of the reformed dental curriculum. In the outpatient clinic, Meharry dentists and dental students applied a high degree of technical skill and experience. In keeping with a Meharry tradition, students and faculty members brought over students from the public schools each year for instruction in the fundamentals of preventive care.

In February 1981, the board of trustees accepted the resignation of Dr. Lloyd Elam. Subsequently, Dr. Elam was named the first chancellor of the college. Pictured are, from left to right, Dr. Richard Lester, Dr. Elam, and Meharry board members.

93

Dr. Lester described his time on the Meharry Board of Trustees and as interim president succeeding President Elam as exciting and a rewarding educational experience. Dr. Lester's crowning accomplishments were the negotiations with the Reagan administration that led the federal government to extend access to the Alvin C. York Veterans Administration Hospital in Murfreesboro, Tennessee, and the assignment of attendings, residents, and medical students to that facility.

THE WHITE HOUSE
WASHINGTON

October 12, 1982

Dear Dr. Lester:

Thank you for your letter of August 3 and for your kind words. I'm sorry this reply has been delayed, but mail sometimes takes awhile to reach my desk.

I am pleased that we have been able to work out a solution to some of the immediate problems facing Meharry. We can all be encouraged by the fact that our system does recognize the contributions of institutions like Meharry, and can respond to their unique circumstances with a helping hand. Meharry has too fine a record, and too much historical significance, to be denied.

You can take personal pride in the role you played to preserve Meharry's status as an academic institution of the first rank, and I fully share your hope and conviction that its greatest days are yet to come.

With my best wishes to you in all of your endeavors,

Sincerely,

Ronald Reagan

Richard G. Lester, M.D.
Department of Radiology
Medical School
The University of Texas
Post Office Box 20708
Houston, Texas 77025

Seven

PRES. DAVID SATCHER
1982–1993

PRES. HENRY WENDELL FOSTER JR.
1994 (ACTING)

Dr. David Satcher served as Meharry Medical College's eighth president from 1982 until 1993. He accepted the presidency at Meharry during a time when the institution was faced with serious challenges. Dr. Satcher will be remembered most for his relentless fortitude and resilience in laying the foundation that eventually resulted in the historic merger of Hubbard Hospital and Metropolitan Nashville General Hospital. Five years after resigning from Meharry, Dr. Satcher became the 16th surgeon general of the United States and served simultaneously as assistant secretary for the US Public Health Service Commissioned Corps.

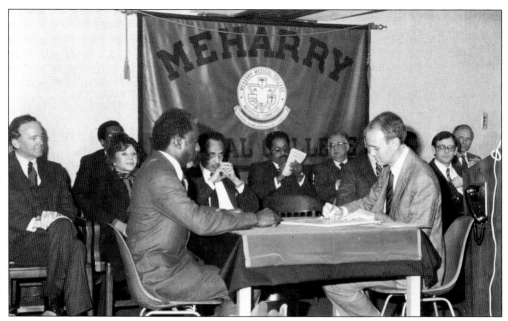

President Satcher (left, at table) joins onlookers as he watches the signing off of Hubbard Hospital's mortgage on February 1, 1983. Pres. Ronald Reagan dismissed the $29 million that remained on the federal loan incurred for the construction of Hubbard Hospital. Seated at the table with President Satcher is Dr. Robert Graham, MD, assistant surgeon general, Department of Health and Human Services.

The historic event took place in a stately closing ceremony in Meharry's Compton-Nelson Auditorium in the S.S. Kresge Learning Resource Center. Members of the Meharry family, government officials, and friends of the college witnessed the official note burning ceremony for the dismissal of the outstanding balance of a federally guaranteed loan used to finance the hospital.

Dr. Satcher instituted the policy that all health professional students at Meharry must pass National Board Part I in order to advance from the basic to the clinical years of training in order to graduate.

Dr. Satcher implemented a comprehensive reorganization plan in the School of Dentistry. He made it a priority to find a new dean for the School of Dentistry. He entrusted the preliminary search to Dr. Charles W. Johnson, vice president for academic affairs. Early in 1983, after an extensive nationwide search, Dr. Rueben C. Warren, DrPH (DDS, 1972), was appointed dean of the School of Dentistry. Dr. Warren served as dean from 1983 to 1988.

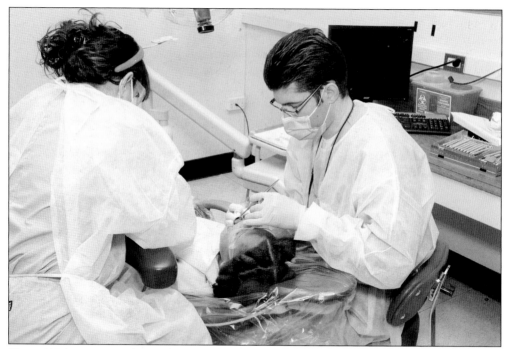

Since 1984, every student who graduated from Meharry in medicine and dentistry has passed both parts of the National Boards prior to graduation. During this period, the college continued to struggle under concerns brought by accrediting agencies.

In 1983, President Satcher's administration outlined the Plan for Academic Renewal, a five-year, $33 million endeavor to increase the number of faculty members and diversity efforts; develop centers of excellence for learning, research, and patient care in the areas of geriatrics, birth defects, nutrition, and infectious diseases; increase financial aid to students and expand library resources and instructional equipment; and renovate the physical plant.

In 1988–1989, Dr. Satcher initiated the Institute on Health Care for the Poor and Underserved. President Satcher noted major changes in the care of the indigent for Medicaid and Medicare. One of his priorities was to make sure Meharry lived up to its mission of being committed to quality health care for its community.

The Minority Research Center of Excellence in Cell and Molecular Biology was established with support from the National Science Foundation during Dr. Satcher's tenure. One goal was to implement nationwide outreach programs to attract college faculty and undergraduates from historically black colleges and universities to participate in summer research and classroom experiences.

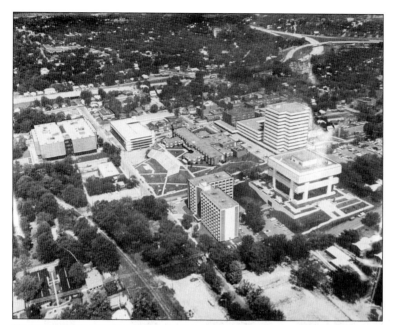

On November 28, 1988, Dr. Satcher's administration presented a proposal to the city of Nashville to close the former Nashville General Hospital and route its indigent care funds to Meharry's Hubbard Hospital rather than rebuild the aging facility at a cost of more than $50 million; the city would move forward with a merger of the two nearly four years later.

Dr. Satcher set the stage for a strategic partnership with Vanderbilt University that continues to benefit Meharry today. He said at the time that Meharry and Vanderbilt must continue to work toward partnership so that this community receives the maximum benefit of medical care and medical education that the two institutions can together provide. It was under the administration of Pres. John Maupin that the memorandum was signed. On October 16, 1998, the Meharry/Vanderbilt Alliance Memorandum of Understanding listed the primary alliance initiatives: clinical sciences, academic support infrastructure, biomedical research collaboration, health services, and the Meharry/Vanderbilt Institute for Primary Care medicine.

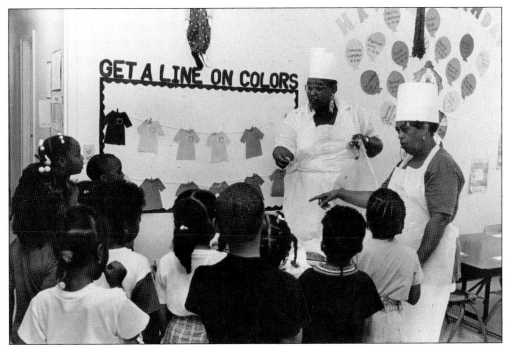

In 1992, The Ill Child Daycare Center at Meharry opened. One of the achievements of the Satcher administration was the establishment of Centers of Excellence, including a Center of Excellence in Nutrition to benefit the children of the region.

Fourteen students, including three masters/doctoral students, graduated from the Department of Anatomy and Physiology. A college that would benefit and nurture students was a priority in the Satcher administration.

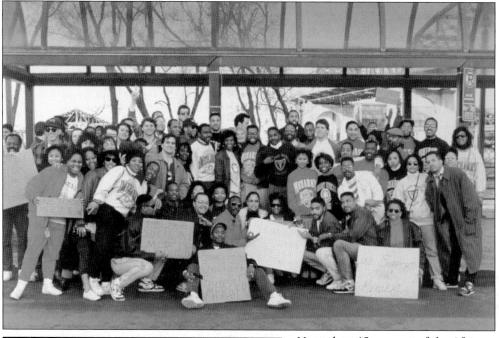

More than 15 percent of the African Americans who receive degrees in medicine and dentistry each year are graduates of Meharry Medical College. Meharry students were anxious to show support for the initiatives of the Satcher administration.

Pictured is a vintage sign in the 1931 Hubbard Hospital. The narrative is indicative of how far hospital policies and procedures have changed over the years during various administrations.

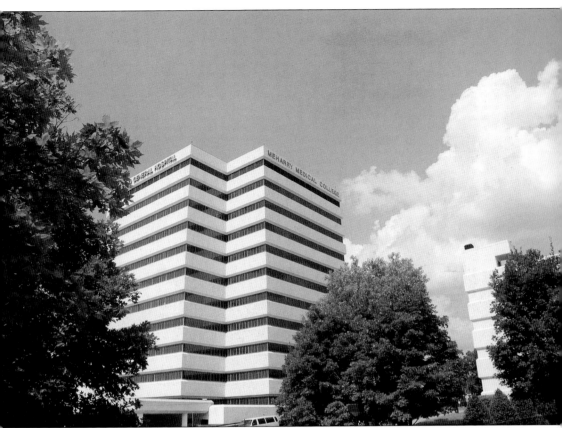

The crowning jewel of Dr. Satcher's administration was the groundwork that eventually resulted in the merger of Hubbard and Metropolitan Nashville General Hospitals and the provision of patient care services by Meharry faculty and students in the new facilities. Dr. Satcher stated that Dick Lester deserved a lot of credit for the developments. While Dr. Satcher did not begin his tenure as president until February 1982, he and Dr. Lester still traveled back and forth to Washington, DC, to lobby the Reagan administration for the venture. They were able to get President Reagan to send a team to Meharry to examine the fact that Meharry had been excluded from the Veterans Administration (VA) hospital. The team first went to Vanderbilt, and Vanderbilt made a major case that it was not going to share the VA hospital, which was on its campus. Meharry's proposal to make Hubbard the city's primary acute and emergency care facility threatened to cut deeply into Vanderbilt's training program for interns and residents. Also, their respective philosophies of medicine were fundamentally different. It was in 1988 that Satcher and Lester introduced the proposal for the merger of Hubbard Hospital and Nashville General Hospital. On August 18, 1992, toward the end of Dr. Satcher's tenure at Meharry, the Nashville Metropolitan Council approved the merger of Nashville General Hospital and Hubbard Hospital. This act represented one of the most significant developments in the history of Meharry Medical College.

In January 1994, Dr. Henry Foster was appointed acting president. He had previously served as the dean of the School of Medicine, was active in the development of the Metropolitan Nashville General Hospital merger plan, and was primarily responsible for recruitment of the physicians necessary to staff Metropolitan Nashville General Hospital/ Hubbard Hospital. Foster's brief tenure will be remembered as essential to the final approval of the merger and a smooth transition of leadership.

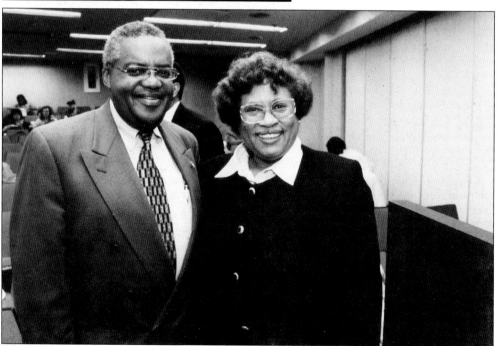

Pictured is Dr. Foster with Surgeon General Joycelyn Elders. Dr. Elders is a pediatrician and public health administrator who served as surgeon general from 1993 to 1994. She visited Meharry during her last year as surgeon general.

Eight

PRES. JOHN E. MAUPIN
1994–2006

Dr. John E. Maupin was the first
alumnus from the Meharry Medical
College School of Dentistry,
graduating in 1972, and was
the second dentist to become
president of the college. From
1994 to 2006, Dr. Maupin was
the ninth president and chief
executive officer of Meharry.
After previous administrations
laid the groundwork, Dr. Maupin
strategically orchestrated the
public-private partnership with
Metropolitan Nashville General
Hospital and Hubbard Hospital. This
partnership was thought to be one
of the most important negotiations
in the history of the college. In
2001, Dr. Maupin led celebrations
of Meharry Medical College's
125th anniversary.

In 1996, Dr. Maupin initiated the Mentorship Program, created in conjunction with the Ob/Gyn Family Practice Training Grant.

The Kresge Foundation of Troy, Michigan, and the Southern Education Foundation of Atlanta, Georgia, partnered in an $18 million initiative aimed at expanding the fundraising operations of 12 historically black colleges and universities. John E. Marshall III (far left), president of the Kresge Foundation, is standing next to President Maupin.

Dr. Sandra and Arnold P. Gold, founders of the Arnold P. Gold Foundation, had recently received a special award from Meharry Medical College's president, Dr. Maupin, for their foundation's contributions to Meharry's first annual white coat ceremony. (Photograph by Johns S. Cross.)

The white coat ceremony recognizes sophomore medical students who will begin hands-on patient care and training. Students who pledge to maintain a high standard of excellence in medicine receive a monogrammed white physicians' coat.

During the white coat ceremony, students also receive a lapel pin and a book of poems and essays on humanism in medicine. The ceremony is held in medical schools across the nation to recognize students entering the clinical phase of medical training.

The Salt Wagon Award is given to those who have served the college in an extraordinary fashion or have made momentous contributions. The year the Salt Wagon Award was given to the descendants of the Meharry family was historical. Several members of the family attended the ceremony.

The 125th anniversary of Meharry Medical College was celebrated during the Maupin administration with joyous festivities. Pictured is Dr. Reuben Warren, class of 1972, dean of the School of Dentistry from 1983 to 1988.

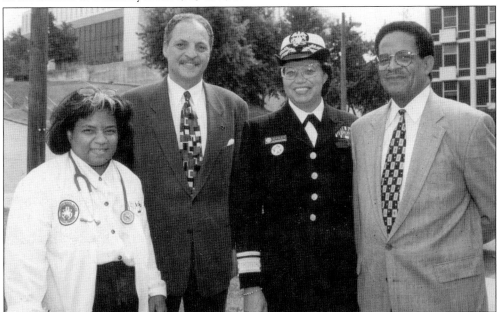

Dr. Maupin was supported by many national leaders. He is pictured here with Surgeon General Jocelyn Elders. Dr. Maupin had been a career dental officer in the US Army Reserve, retiring in 1996 with more than 28 years of service, including two years active duty at the Walter Reed Army Medical Center in Washington, DC, and nine months of active duty service during Operation Desert Shield/Desert Storm.

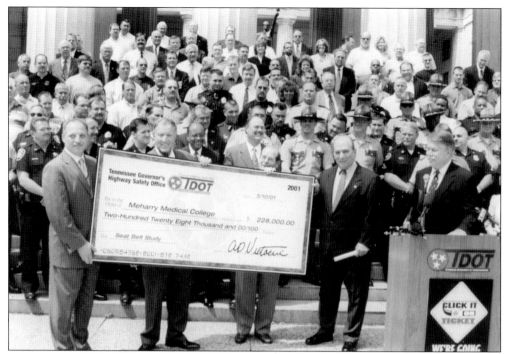

Among many of President Maupin's accomplishments was the ability to raise funds. Pictured is Dr. Maupin receiving a check from the Tennessee Department of Transportation for the amount of $228,000 in 2001.

Match day in the graduate education community is the day when the National Resident Matching Program releases result to applicants seeking residency and fellowship training positions in the United States. Pictured are students at a 2002 match day event.

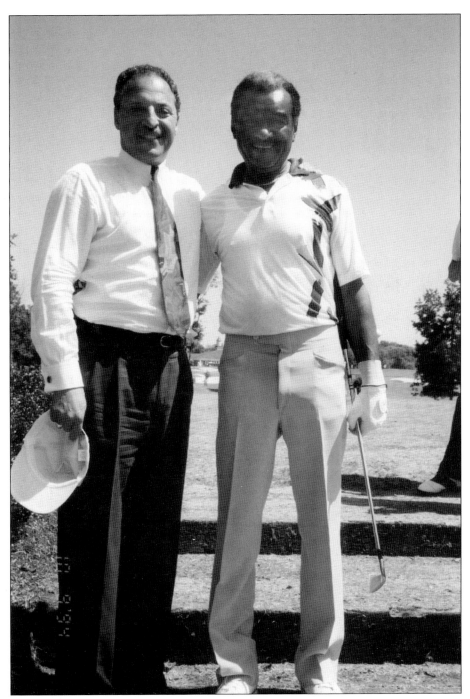

Dr. Maupin recognized that the college needed a lot of financial assistance to accomplish the goals he had set forth for his administration. The buildings needed repair. He stated that the declining campus facilities affected public opinion of Meharry. He reasoned that the condition of the campus meant that Meharry was a place of last resort for patients and students and not highly regarded. He began a campaign to raise funds through various initiatives. The Sara Lee Golf Classic was one of many fundraising endeavors.

The Salt Wagon Award given during one year of Maupin's administration was presented to Leatrice McKissack. The McKissack family is noted for being the first black architectural firm in the nation. Pictured with Dr. Maupin is Leatrice McKissack (center) and Eilene Maupin (right).

The 125th anniversary of the college included a huge birthday cake decorated with an emblem of the college. Dr. Frank Royal Sr., MD (class of 1968), is pictured cutting the first slice of cake at the celebration.

Nashville mayor Philip Bredesen (wearing a physician's coat) cuts the ribbon officially opening Metropolitan Nashville General Hospital, which relocated to the Meharry campus on January 11, 1998. To the left of the mayor is former Meharry president and US surgeon general Dr. David Satcher. To the right of the mayor is Dr. John E. Maupin Jr., president of Meharry. (Photograph by John S. Cross.)

Dr. Maupin participated in numerous commencement ceremonies. He is seen here giving an address. Dr. Maupin had a passion for Meharry. He made it his mission to restore many of the deteriorating buildings on campus during his administration.

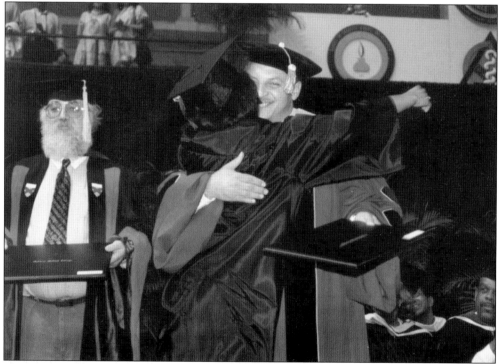

The conclusion of Meharry medical students' years of studies is the joyous celebration of commencement. Pictured is one student exuberantly hugging President Maupin. The student body at Meharry is diverse; more than half of them are women. The students in general share one important trait, though—they are strongly dedicated to serving the health needs of the underserved.

Nine

PRES. WAYNE RILEY
2007–2013
PRES. CHERRIE EPPS
2013–2015

On January 1, 2007, Dr. Wayne Joseph Riley became the 10th president and chief executive officer of Meharry Medical College, his father's alma mater. Under Dr. Riley's leadership, Meharry made significant strides in securing philanthropic support from the National Institutes of Health, allowing enhancement of the clinical and academic programs. Among a few of Dr. Riley's achievements was the reaffirmation of accreditation by the Southern Association of Colleges and Schools and the American Dental Association, the first ever accreditation for the master's degree program in public health, and receipt of an $18 million gift from the Robert Wood Johnson Foundation.

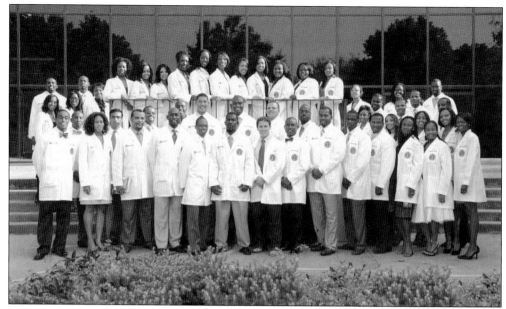

The white coat ceremony was held in the School of Dentistry as well as the School of Medicine. Pictured is the class of 2011 School of Dentistry proudly posing in their white coats.

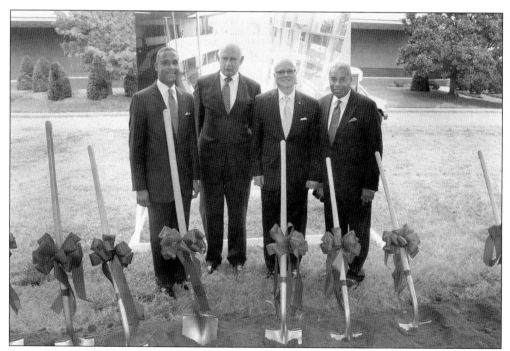

During the Riley administration, the Cal Turner Building was erected. The building was named for Cal Turner, son of the founder of the Dollar General store, as he gave the initial $3 million to begin construction.

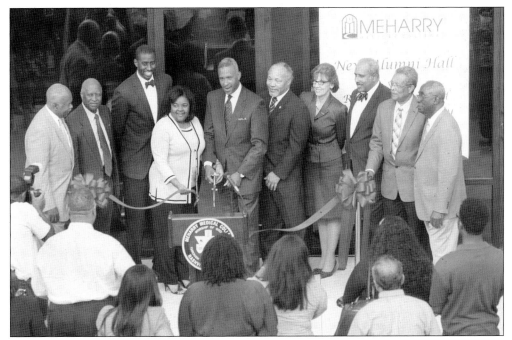

The ribbon-cutting ceremony for a new Alumni Hall took place during the Riley administration. It was dedicated as the Henry A. Moses, PhD Alumni Hall. Pictured at center is Dean Cherae Farmer-Dixon with President Riley.

Dr. Riley was a popular president among the students. Posed with him are students from the School of Graduate Studies and Research.

In 2012, Dr. Riley was selected by the *Nashville Business Journal* as the 2012 Healthcare CEO of the Year. In the same year, he was elected to the Institute of Medicine (IOM) membership organization. Election to the IOM is considered one of the highest honors bestowed in medicine and science.

Anna Cherrie Epps served as the first woman interim president in 2007. In 2009, Dr. Epps wrote, in collaboration with Patricia Morris Hammock, *An Act of Grace: The Right Side of History*. Seven years in the making, the book chronicles Meharry's tumultuous history and the college's spirit of survival. Pictured is Dr. Riley with Dr. Epps signing a copy of the book.

In 2013, Dr. Epps was named the 11th president of Meharry Medical College. She was the only African American woman with a doctorate to become dean and then president of a historically black college and university. For three years prior to her formal appointment as dean of the School of Medicine, Dr. Epps had served as special advisor to President Maupin, chair of the Medical Education Advisory Committee, interim dean of the School of Medicine, interim vice president for academic affairs, and visiting professor of internal medicine. Dr. Epps was driven by the power of her knowledge and experience to resolve Meharry's cascade of challenges. The end result was a sense of trust and belief in the value of community within the workplace that prevailed throughout her tenure.

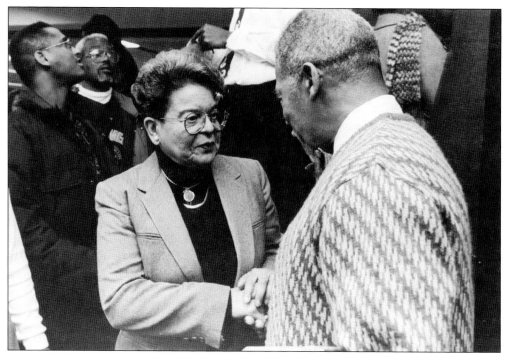

Dr. Epps served the community with quality and compassionate health care services. She emphasized the unique mission of educating and training the next generation in health care professions who will perform services to benefit all society, especially the poor and underserved.

The Anna Cherrie Epps sign commemorates the loyalty and support of Meharry Medical College. Dr. Epps noted her goals were clear from the beginning: quality, confidence, and accountability.

Ten

PRES. JAMES E.K. HILDRETH
2015–PRESENT

Best known for his groundbreaking work on AIDS and HIV research, in 2015, James E.K. Hildreth, PhD, MD, became the 12th president and chief executive officer of Meharry Medical College. Hildreth has published more than 90 scientific articles and holds 11 patents based on his research. Prior to becoming president, Dr. Hildreth was director of the NIH-funded Center for AIDS Health Disparities Research at Meharry in 2005. President Hildreth has been recognized nationally for his expertise in infectious diseases. Through the leadership of Dr. Hildreth, Meharry Medical College has gained national recognition as a leading medical research institution in the fight against SARS-CoV-2, one of many viruses that has plagued the world in recent years.

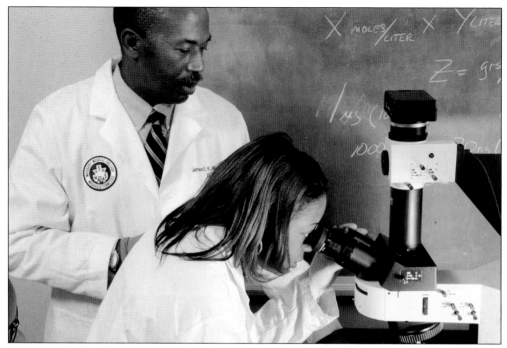

Ten years before he became Meharry's 12th president, Dr. Hildreth was affiliated with the college as director of the Center for AIDS Health Disparities Research on campus. Current research projects undertaken at the center are funded by the National Institute on Drug Abuse/National Institutes of Health, the Vanderbilt Clinical Translational Science Award Program, and the Pittsburgh Center for HIV Protein Interaction at the University of Pittsburgh.

President Hildreth congratulates a medical student during a white coat ceremony on campus. In September 2020, Hildreth accepted a $34 million gift from Bloomberg Philanthropies—a portion of its $100 million donation to four medical schools at historically black colleges and universities—and announced that Meharry's medical students would be eligible for a $100,000 scholarship.

Under President Hildreth's administration in October 2020, the college announced a new partnership with Fayetteville State University (FSU) in North Carolina that would boost its medical school enrollment. The two HBCUs established a program allowing premed students who study at FSU for three years to then study for another three years at Meharry as medical students, finishing with three years of residency in Cumberland County, North Carolina.

During President Hildreth's tenure, in September 2020, the School of Dentistry received $15,000 from the Tennessee Academy of General Dentistry to help fund renovations to Meharry's prosthodontic clinic on campus. Delta Dental of Tennessee matched those funds to contribute to the renovation, which would allow dental students to continue to care for community patients under the supervision of faculty members.

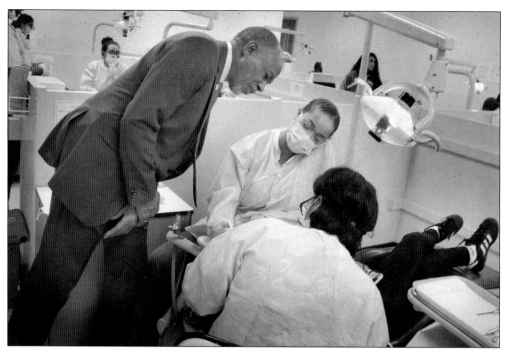

In February 2020, at Meharry's annual Oral Health Day held in the School of Dentistry and across campus, President Hildreth observes dental students' work on a patient from the community. Dental students and residents work with faculty members and dentists to provide free extractions, fillings, and cleanings.

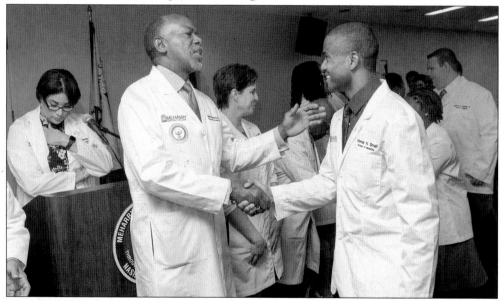

In October 2020, President Hildreth announced a partnership with Tennessee State University (TSU) in Nashville to create the Levi Watkins Accelerated Training Program, which would ensure five students would study in Meharry's School of Medicine and another five students would study in Meharry's School of Dentistry after having studied for three years at TSU.

Under President Hildreth's administration, Meharry scientists developed a SARS-CoV-2 COVID-19 vaccine. Hildreth participated in the initial vaccine trial in October 2020. After the pandemic began, Hildreth often appeared with Nashville mayor John Cooper on television during his frequent COVID-19 press conferences, educating the city as its resident public health expert on the impact of the worldwide pandemic.

President Hildreth discusses protocol during the summer of 2020 with Meharry staff members working at the SARS-CoV-2 COVID-19 testing site on campus. The college's site was one of three testing sites set up throughout the city of Nashville, all of which were managed by the college during the pandemic, bringing in needed funding during the nation's economic downturn.

As the SARS-CoV-2 COVID-19 pandemic began its second spike throughout the United States in October 2020, Dr. Hildreth was appointed to the Federal Drug Administration's 20-member Vaccines and Related Biological Products Advisory Committee. Infectious disease experts such as Hildreth joined other experts from the FDA, the Centers for Disease Control and Prevention, and the National Institutes of Health, among other institutions, to determine upcoming COVID-19 vaccine efficacy.

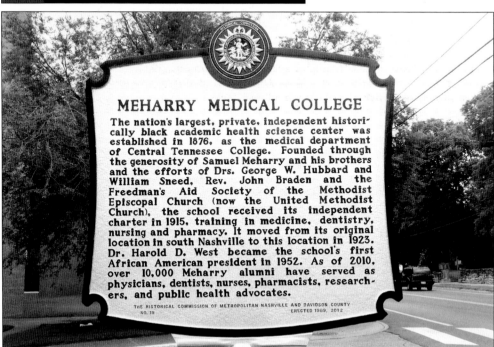

The Meharry Medical College historical marker tells the beginning of the Meharry story. May the purpose to which it is dedicated be fully realized: "The Worship of God through Service to Man."

BIBLIOGRAPHY

Dummett, Clifton O., and Lois D. Dummett. *Dental Education at Meharry Medical College: Origin and Odyssey*. Nashville, TN: Meharry Medical College, 1992.

Epps, Anna L. Cherrie, and Patricia M. Hammock. *An Act of Grace: The Right Side of History*. Baltimore, MD: Johns Hopkins University Press, 2009.

Johnson, Charles W. Sr. *The Spirit of a Place Called Meharry: The Strength of Its Past to Shape the Future*. Franklin, TN: Hillsboro Press, 2000.

Leach, J. Leonidas, ed. *The Meharry Annual and Military Review*. Nashville, TN: Sunday School Publishing Board of the National Baptist Convention Inc., 1919.

McHollin, Mattie. "A Condensed History of Meharry Medical College." Unpublished manuscript, 1982.

Roman, Charles V. *Meharry Medical College: A History*. Nashville, TN: Sunday School Publishing Board of the National Baptist Convention Inc., 1934.

Summerville, James. *Educating Black Doctors: A History of Meharry Medical College*. Tuscaloosa, AL: University of Alabama Press, 1983.

DISCOVER THOUSANDS OF LOCAL HISTORY BOOKS FEATURING MILLIONS OF VINTAGE IMAGES

Arcadia Publishing, the leading local history publisher in the United States, is committed to making history accessible and meaningful through publishing books that celebrate and preserve the heritage of America's people and places.

Find more books like this at
www.arcadiapublishing.com

Search for your hometown history, your old stomping grounds, and even your favorite sports team.